Franko B. Oh Lover Boy.

© 2001 Franko B,
Manuel Vason, Gray Watson,
Sarah Wilson &
Black Dog Publishing Ltd

Designed by
Maria Beddoes & Paul Khera
with Scott Lee Cash

Photography by
Manuel Vason

Printed in the
European Union

British Library cataloguing-in-
publication data. A catalogue
record is available from the
British Library.

The Gray Watson text is an
edited version of an interview
held in June 2000.
The original interview is
available in audio cassette
from Audio Arts.
For further information,
please call 0207 720 9129

Black Dog
Publishing Limited
PO Box 3082
London nw1 uk

T 020 7613 1922
F 020 7613 1944
E info@bdp.demon.co.uk

ISBN 1 90103 382 1

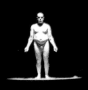

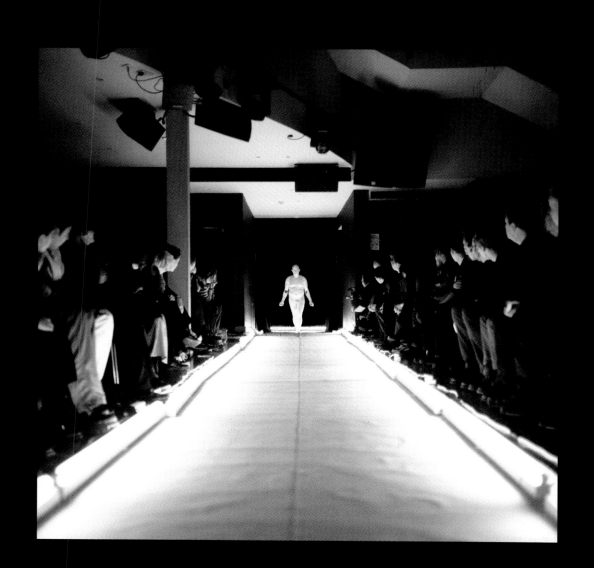

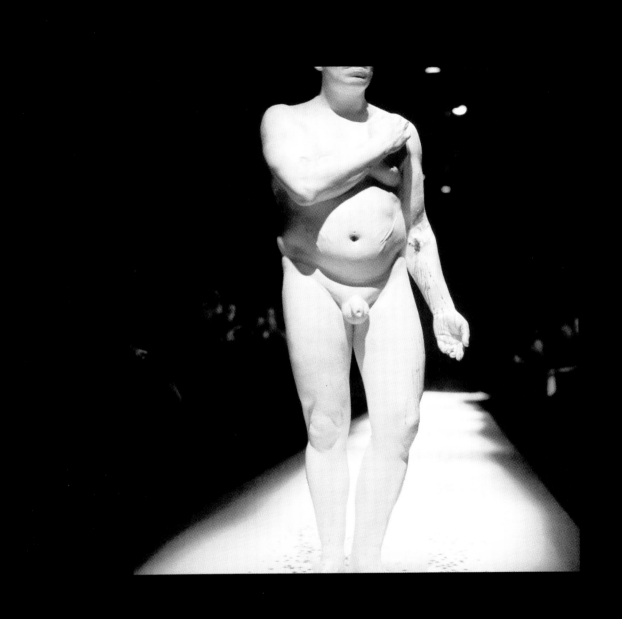

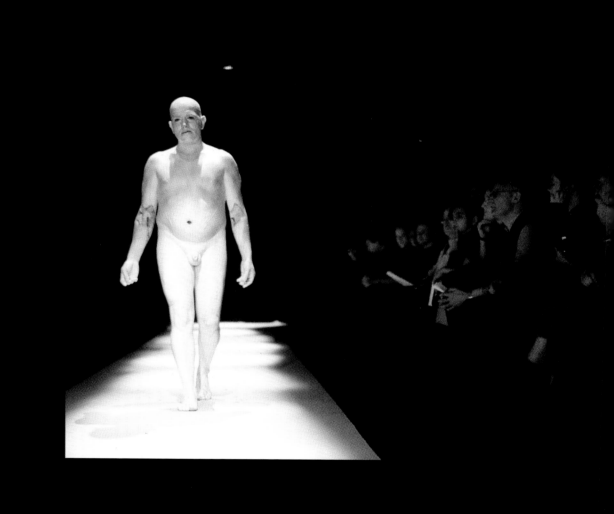

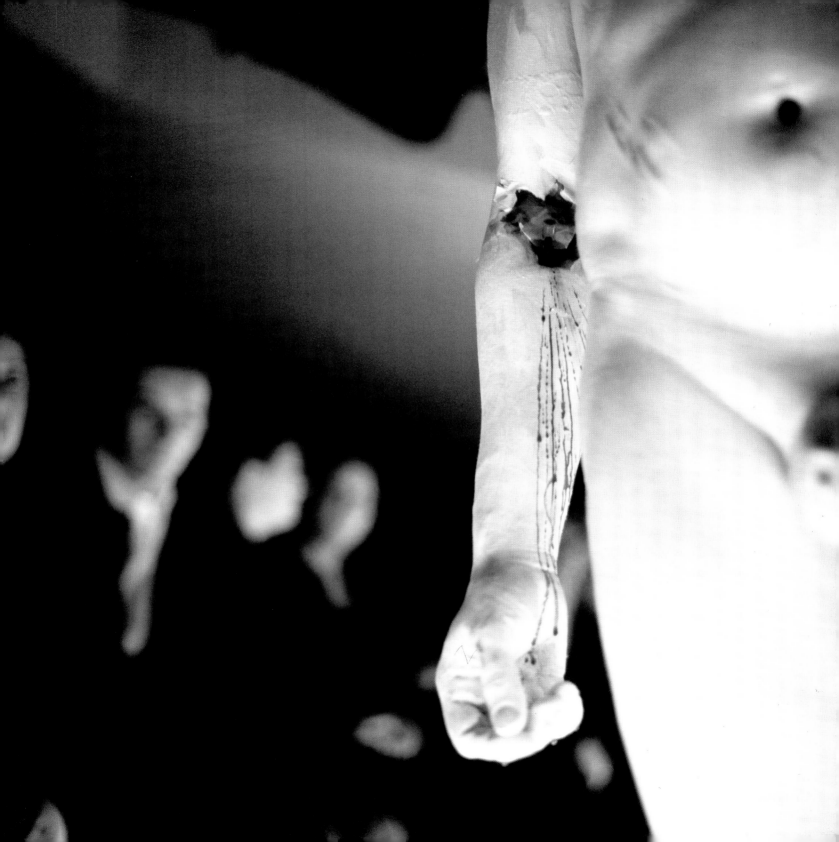

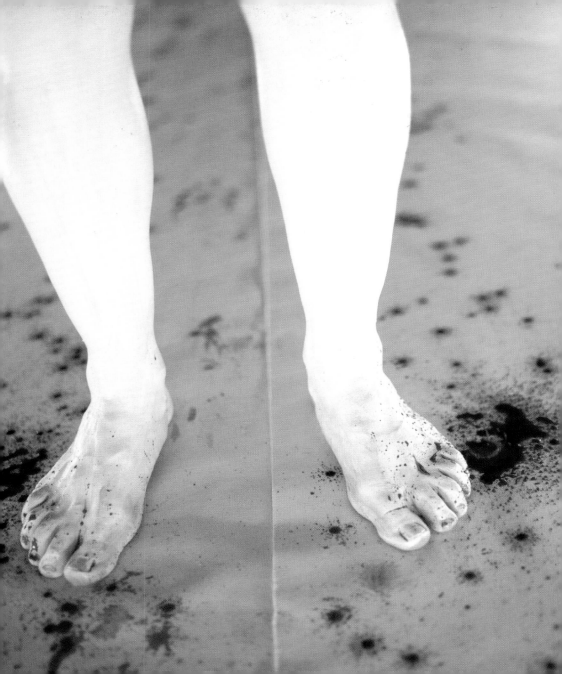

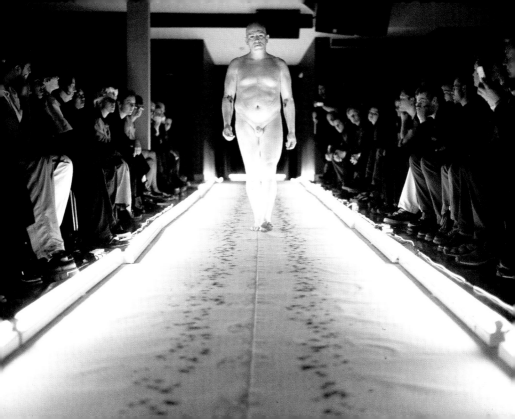

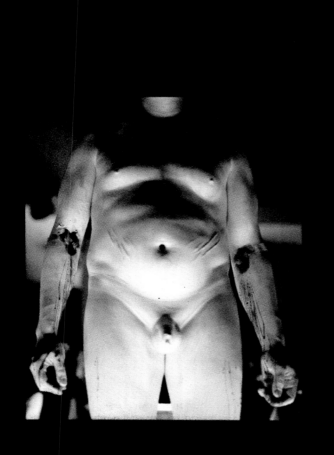

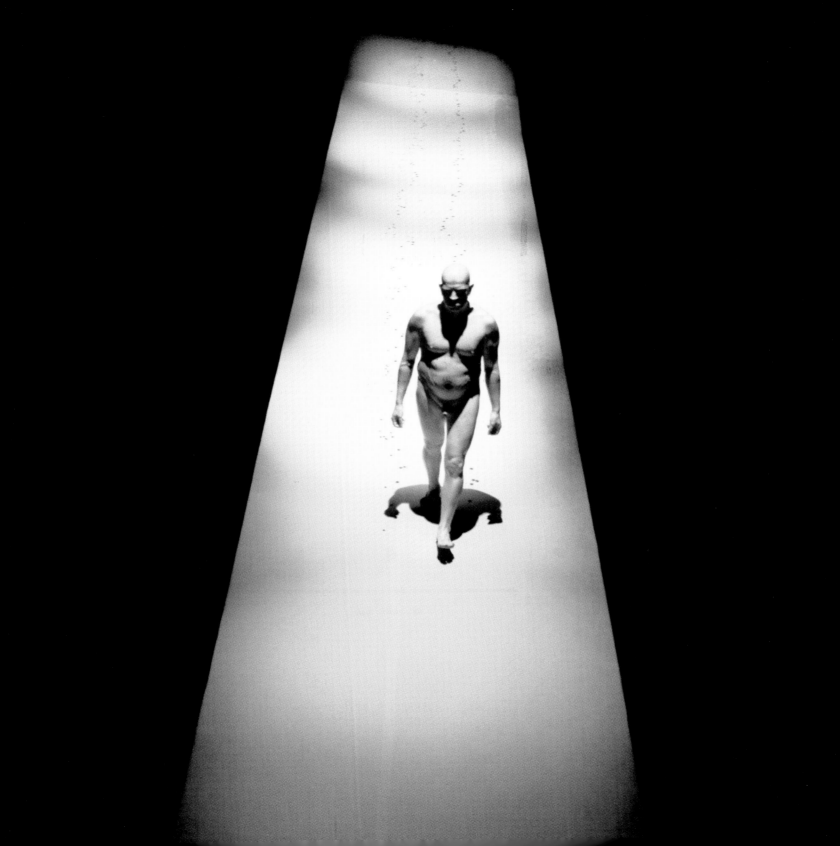

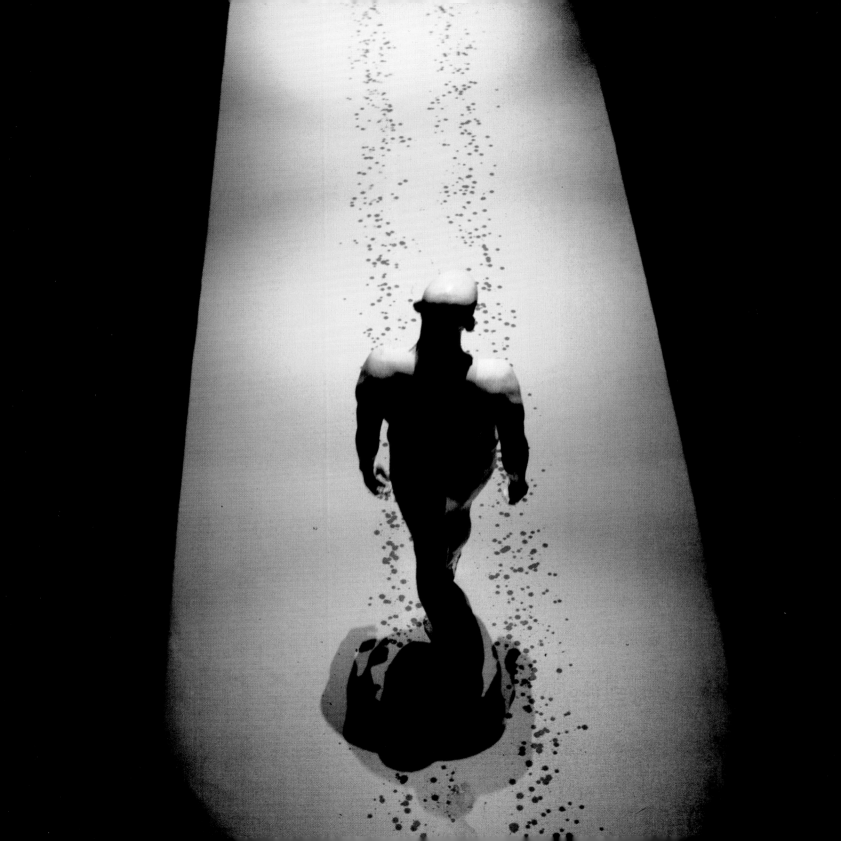

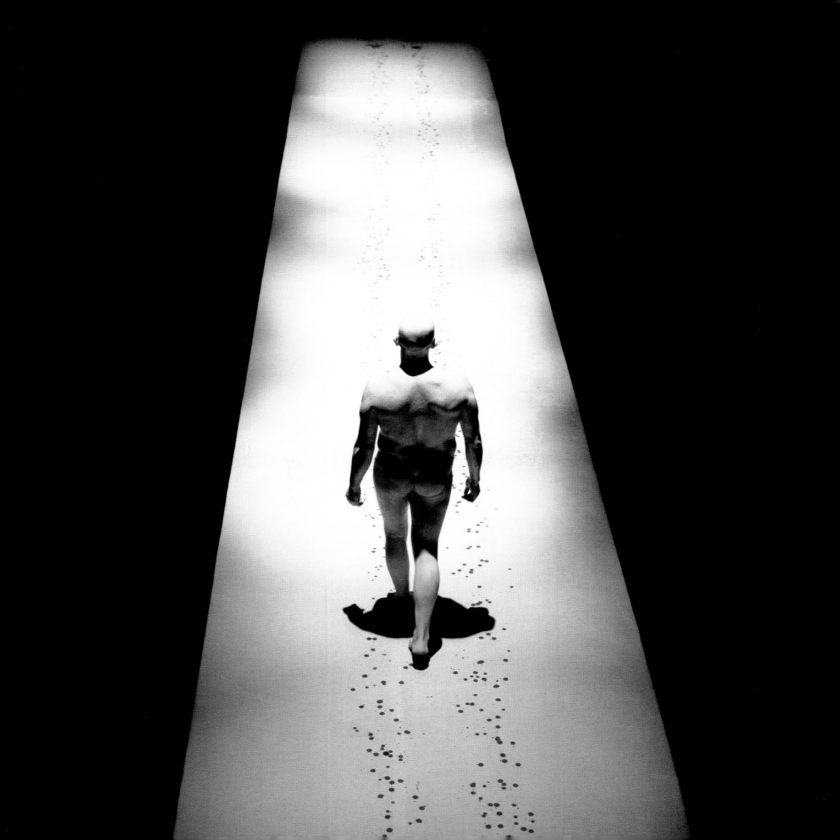

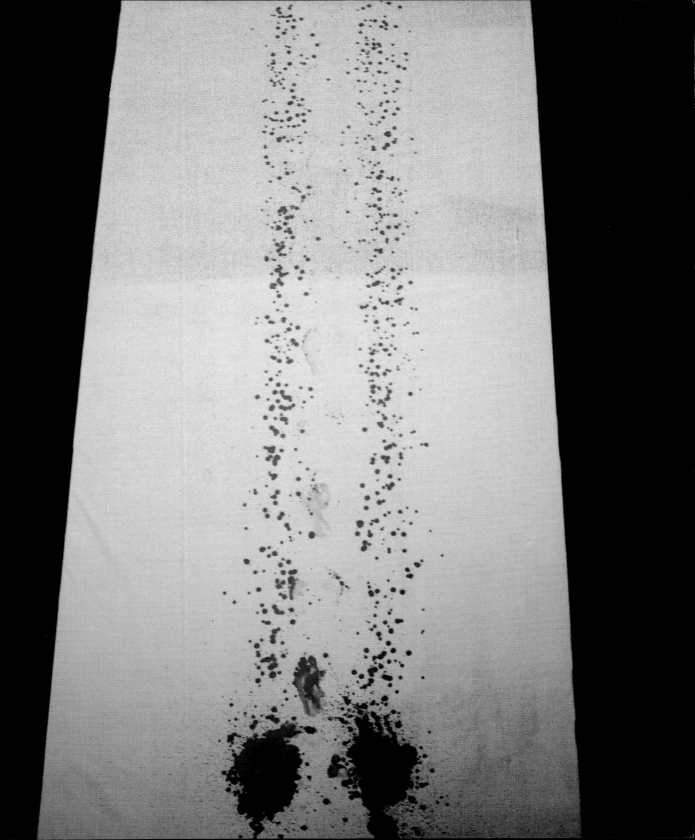

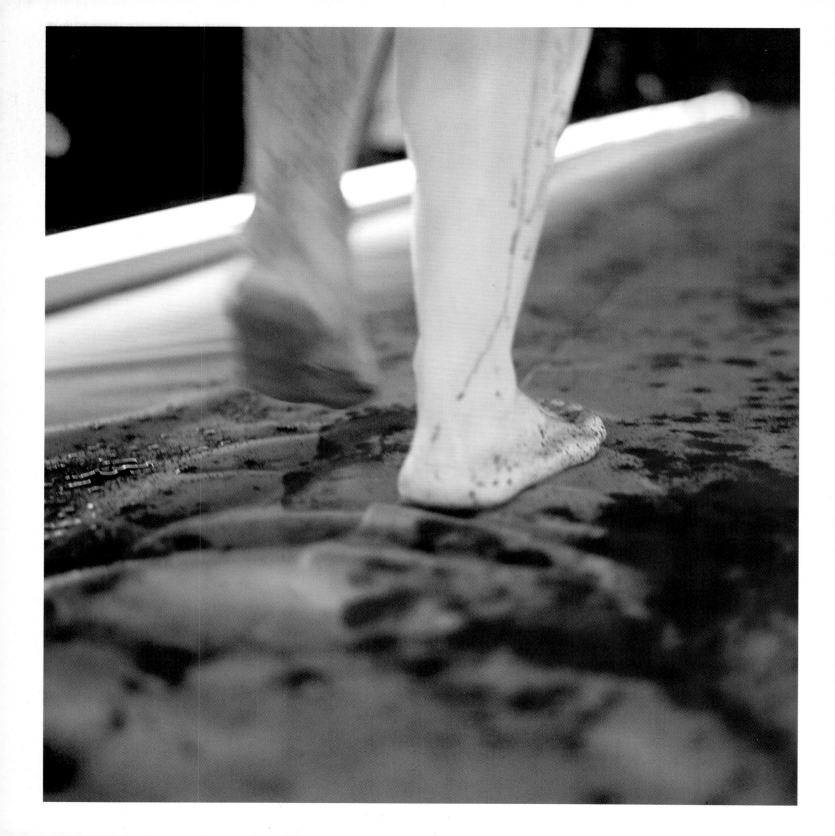

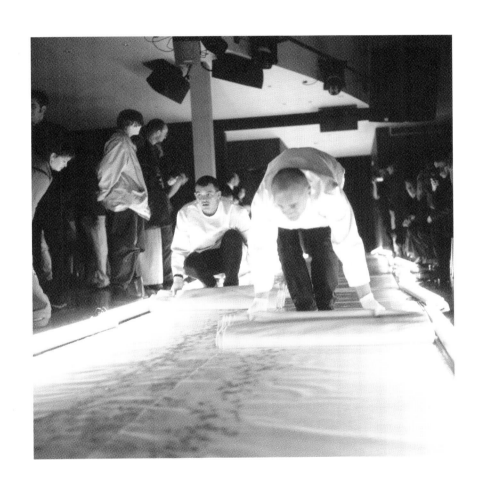

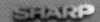

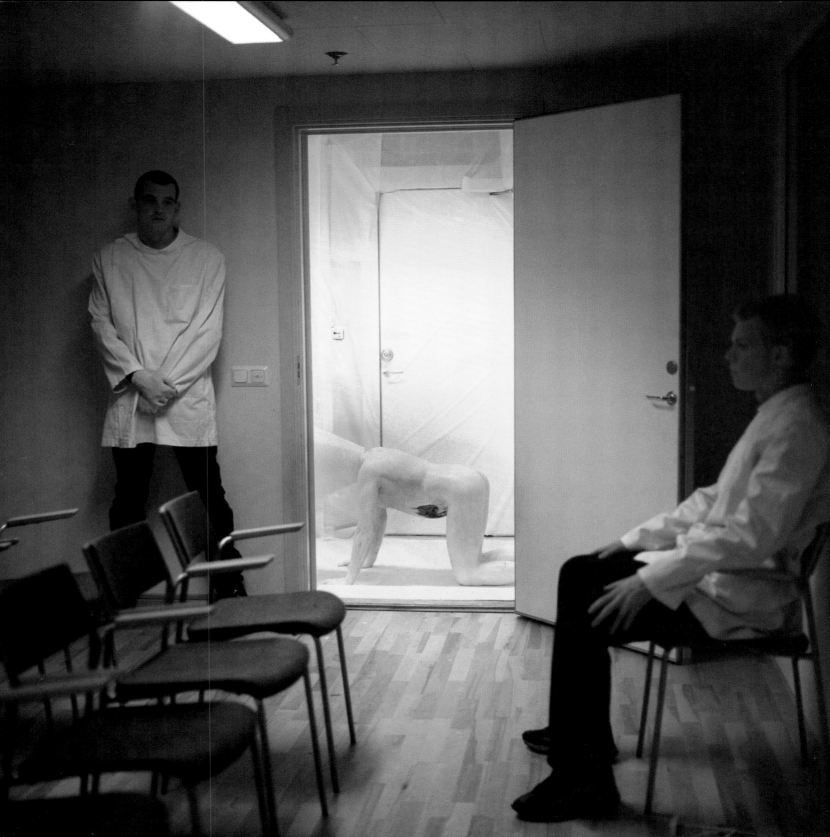

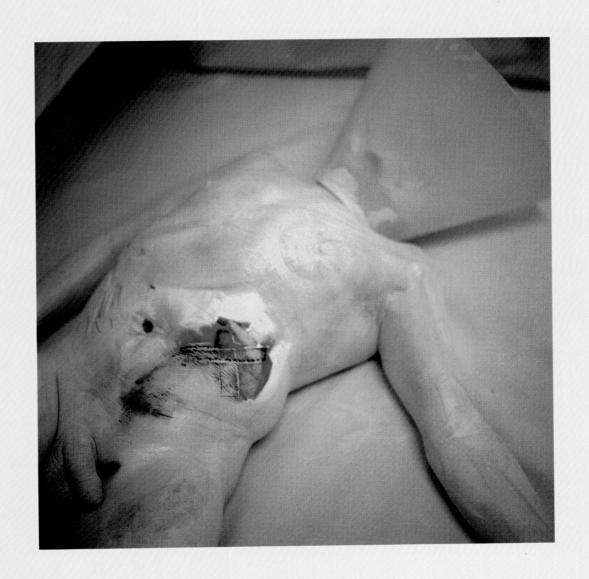

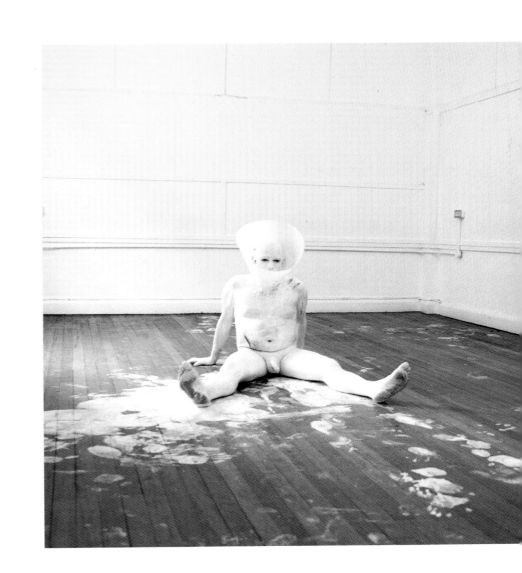

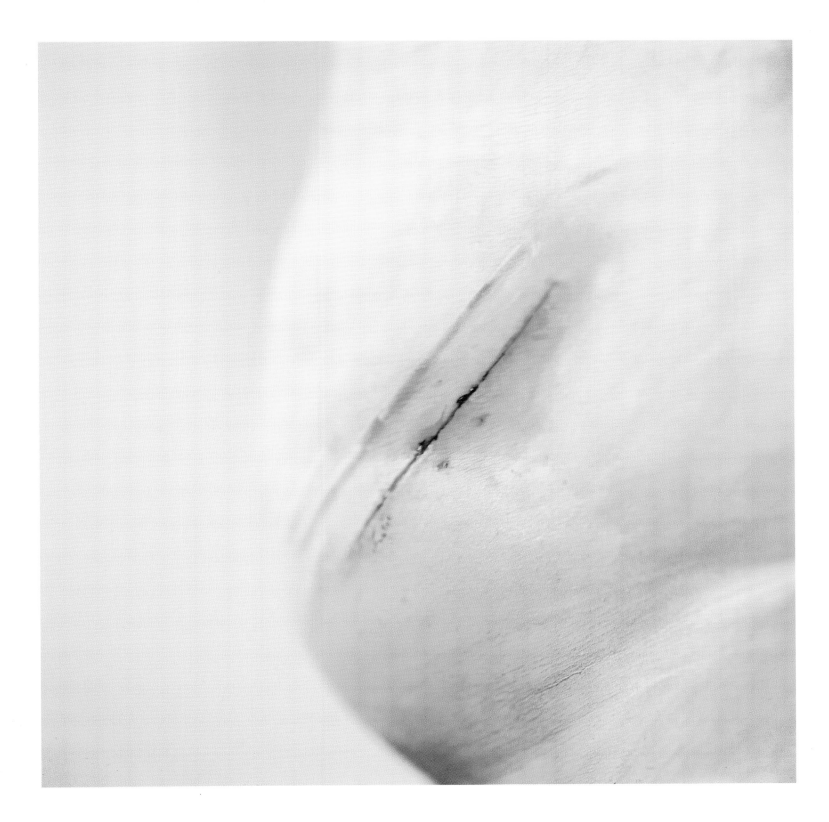

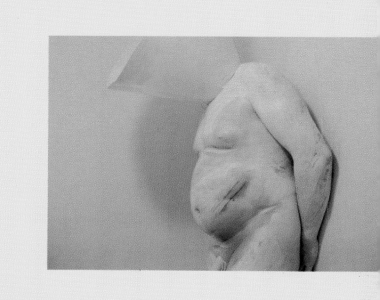

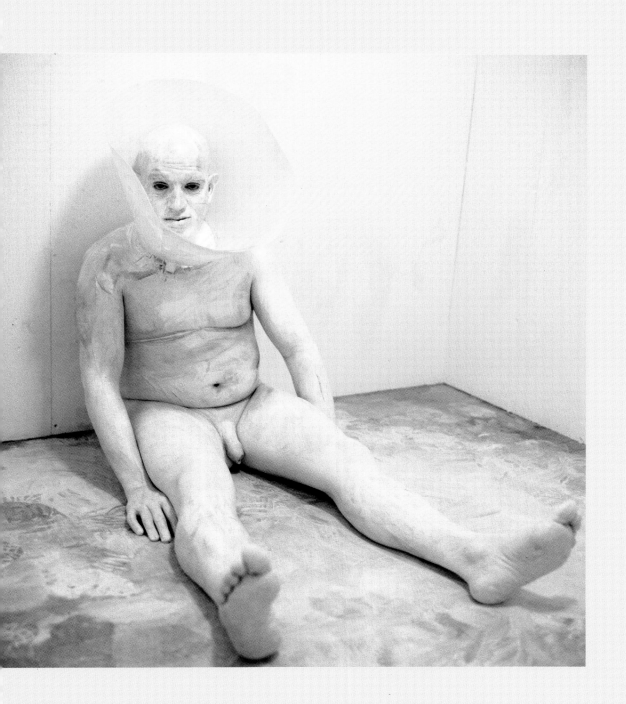

mama i

can't sing

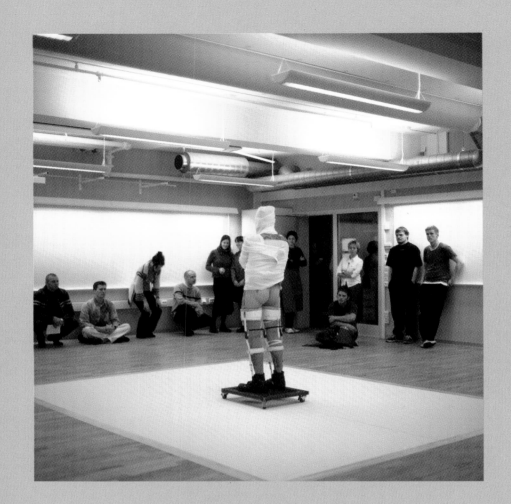

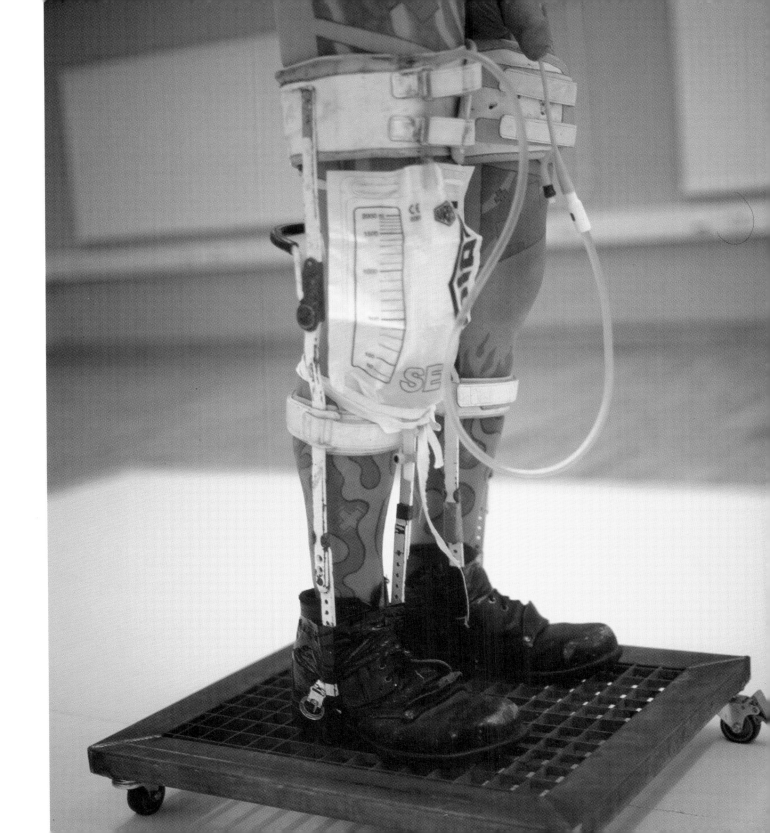

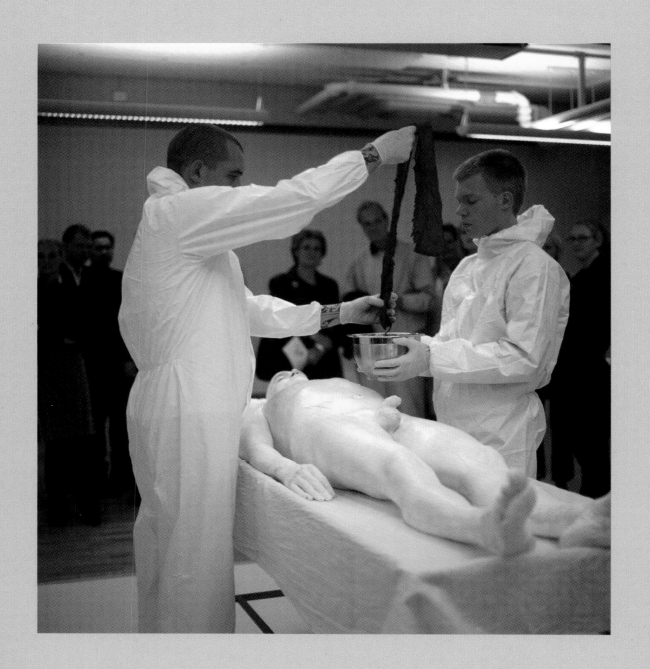

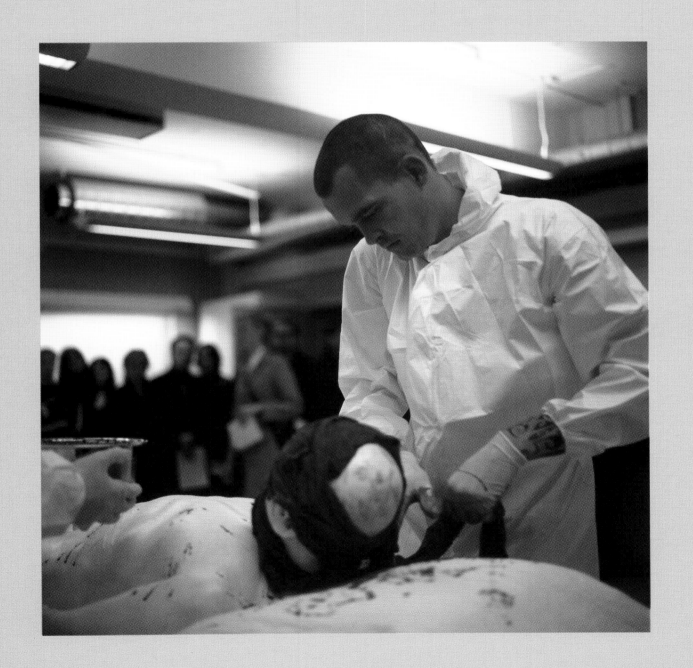

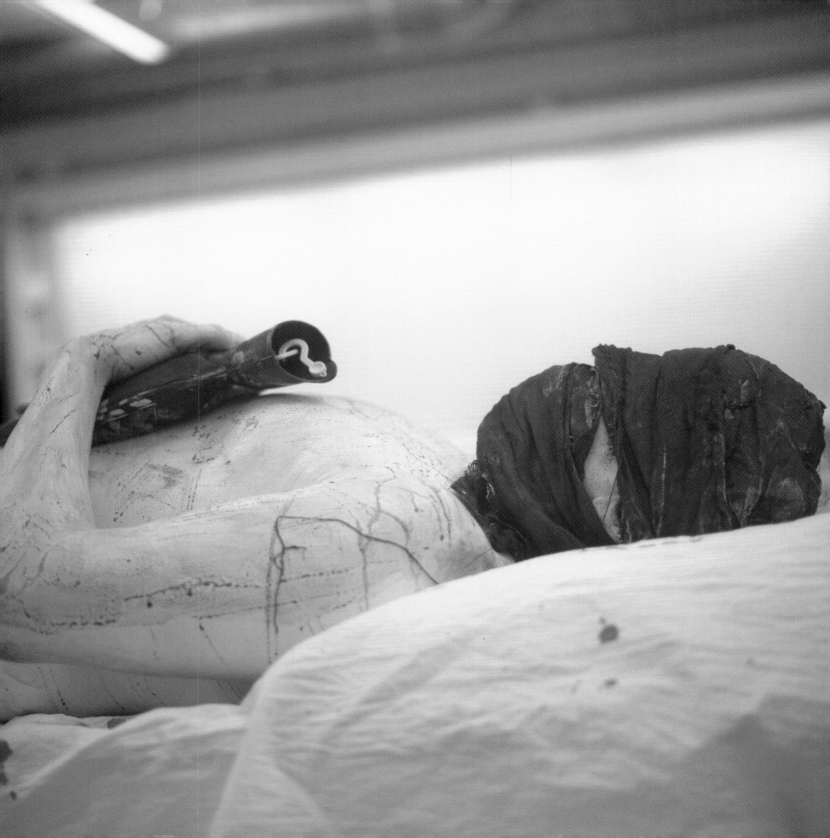

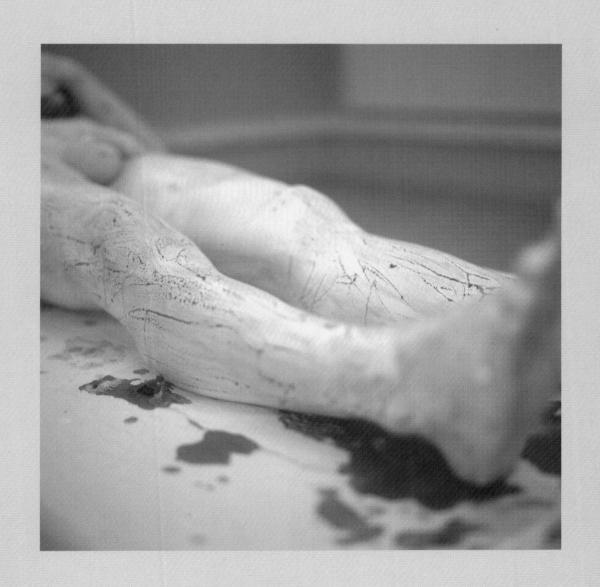

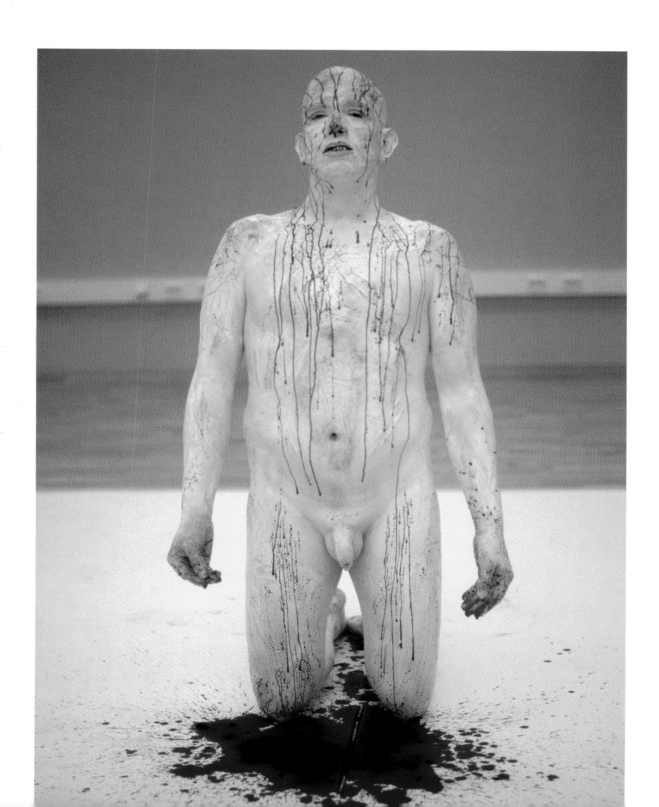

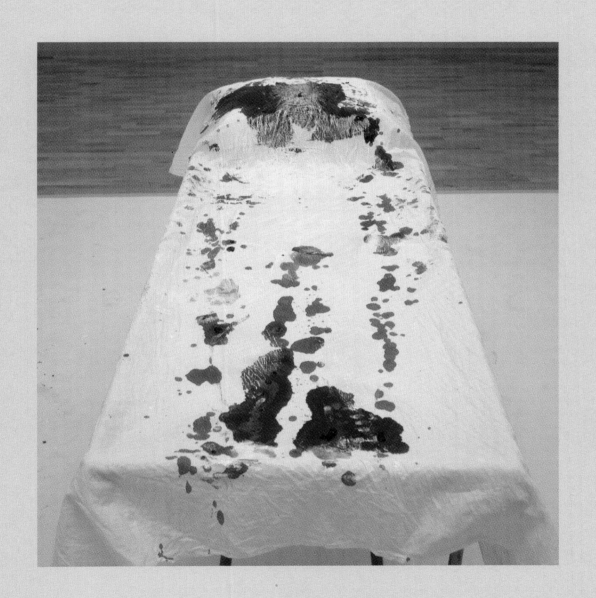

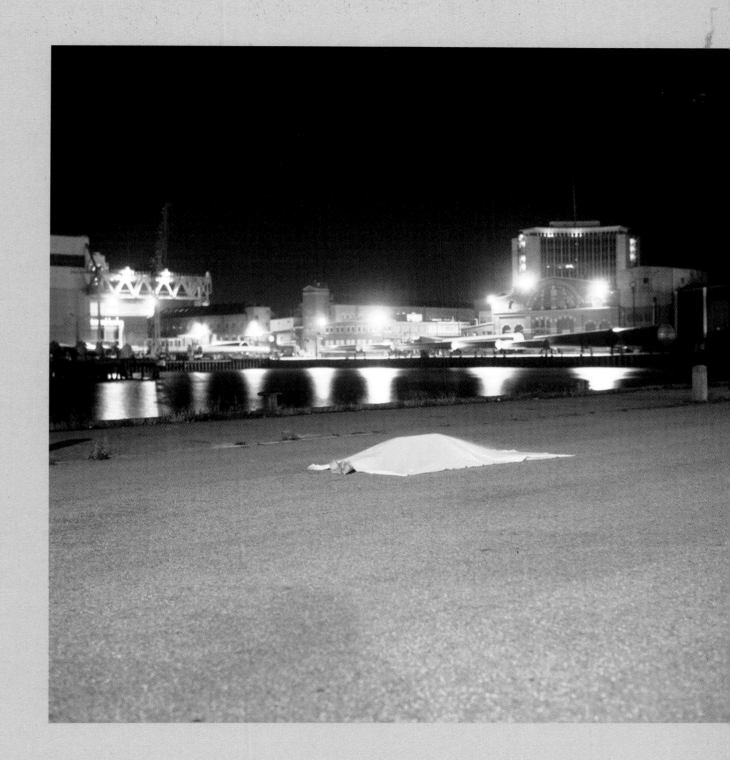

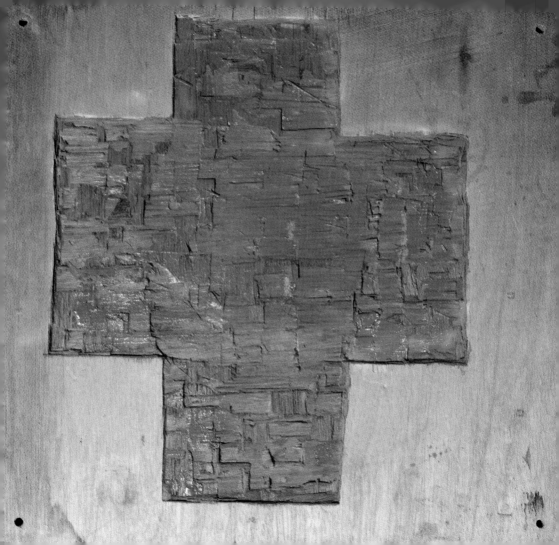

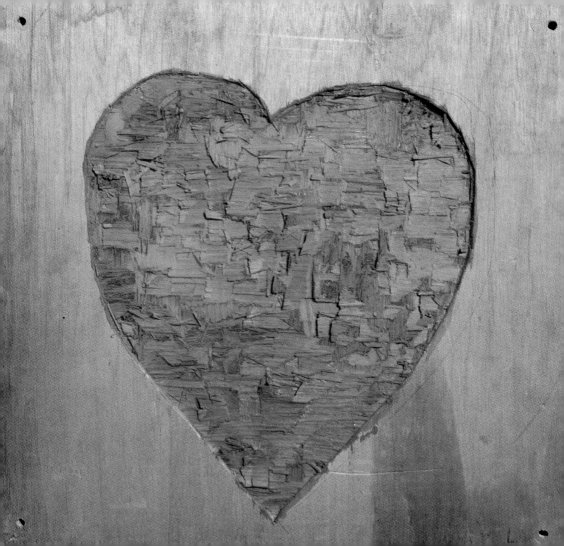

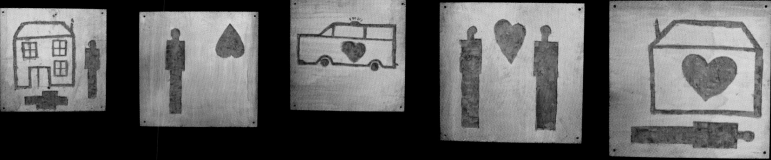

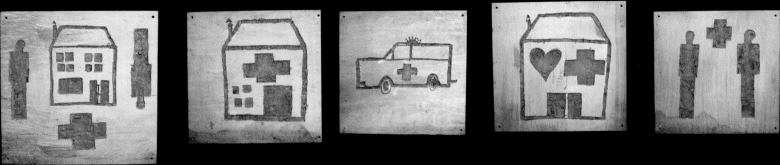

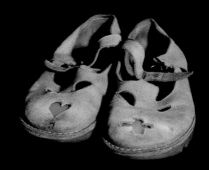

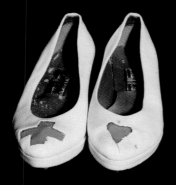

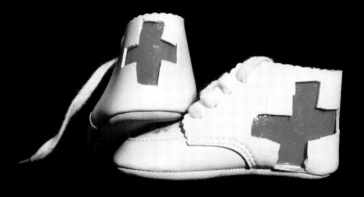

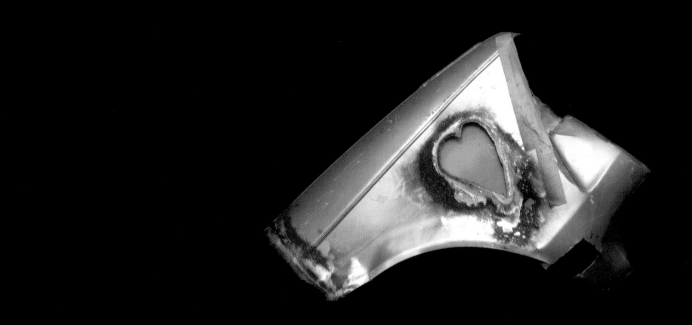
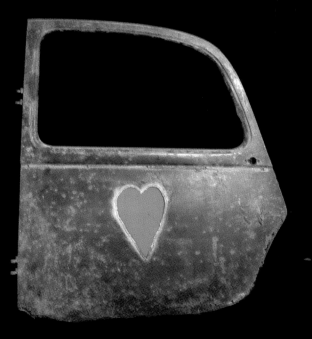

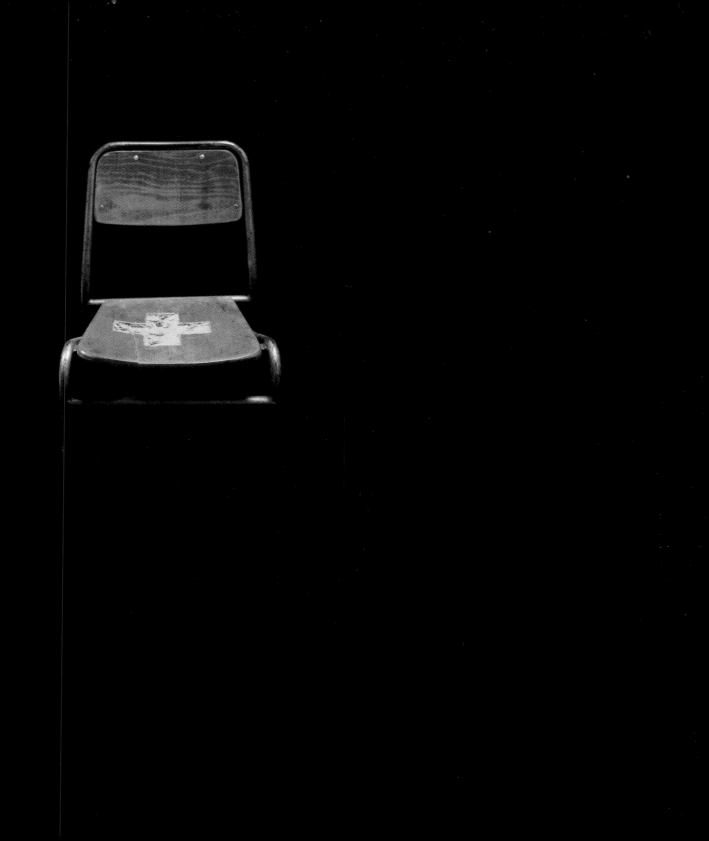

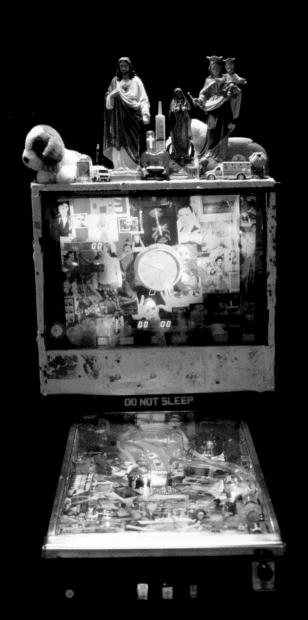

DO NOT SLEEP

...with special thanks to Pinball Geof

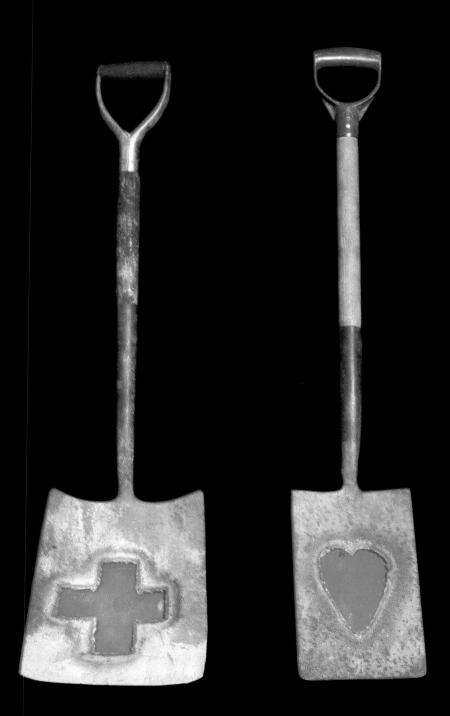

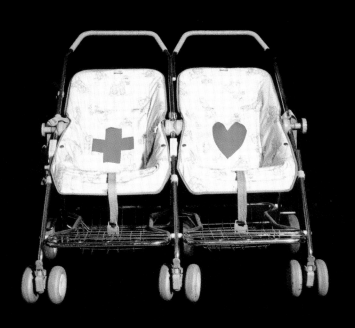

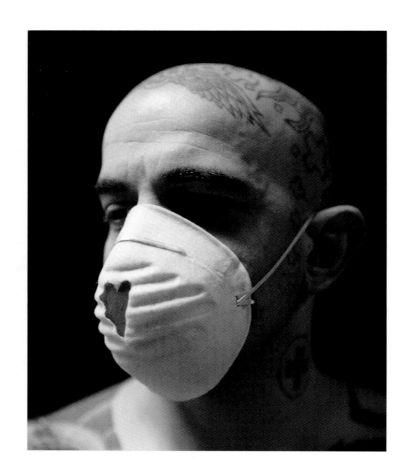

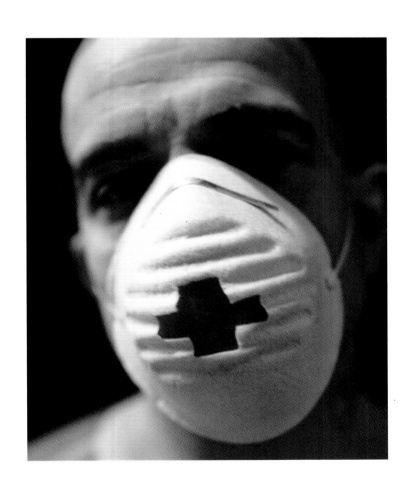

you make my heart go boom boom

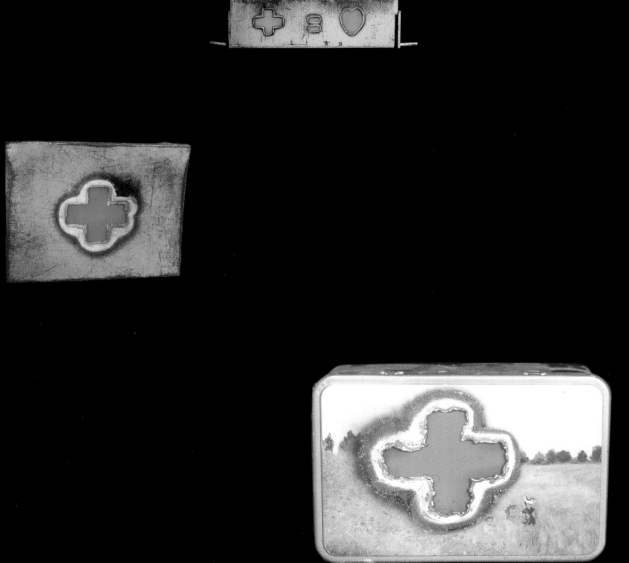

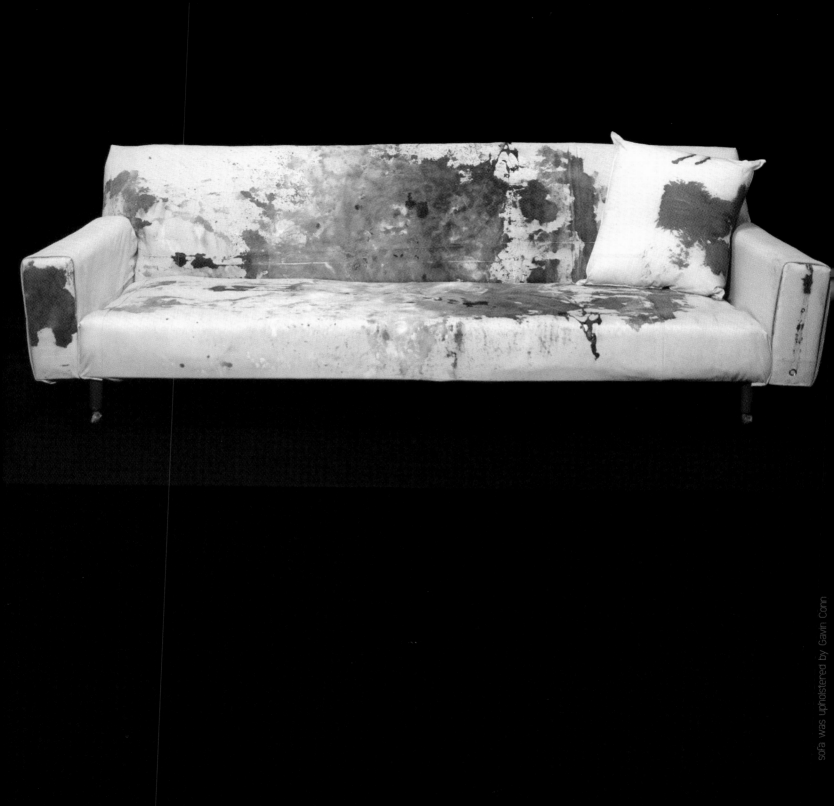

sofa was upholstered by Gavin Conn

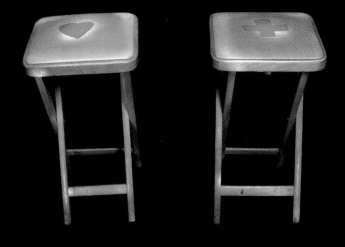

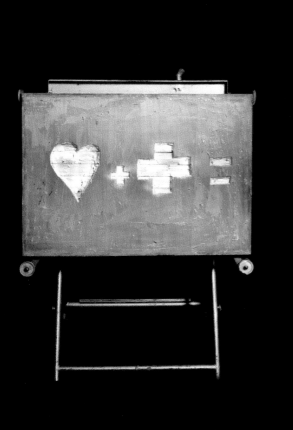 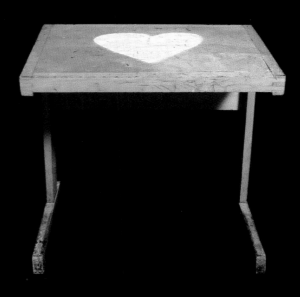

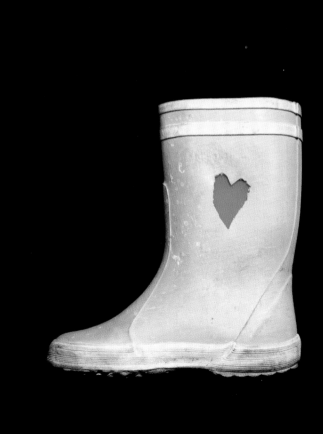

lover boy

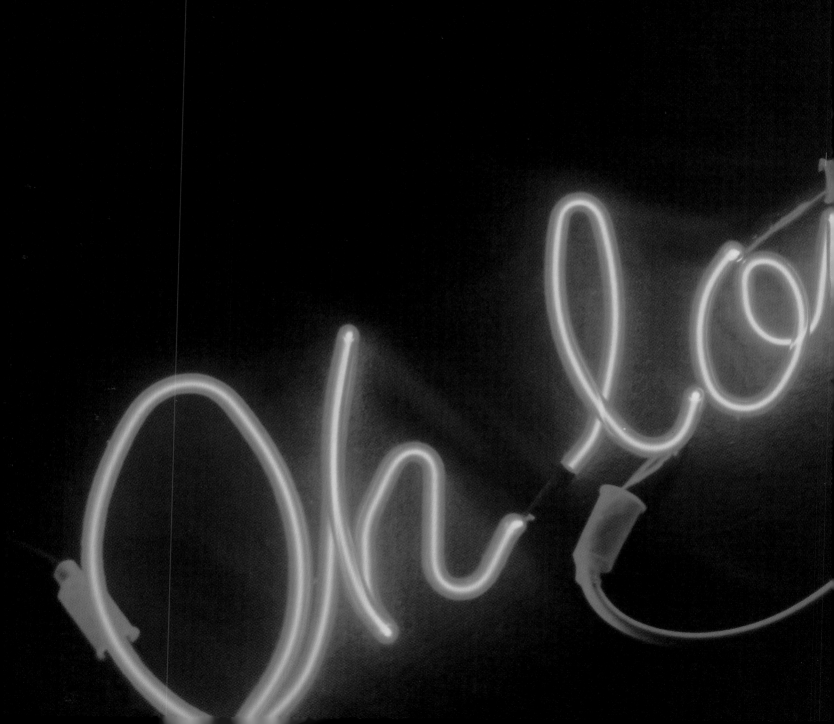

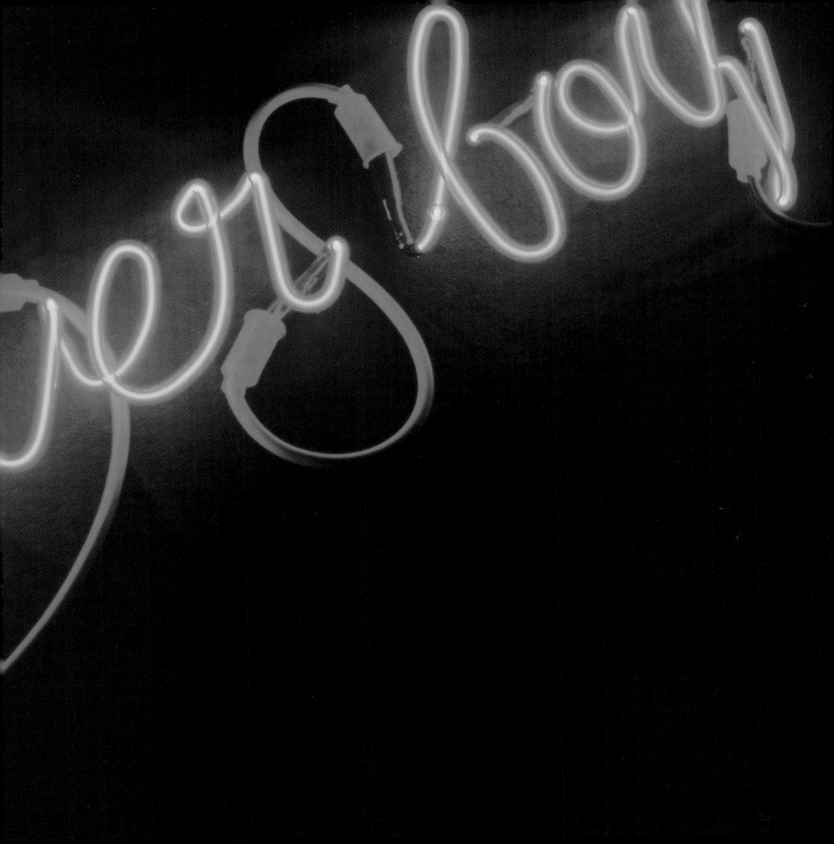

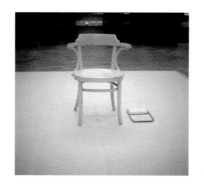

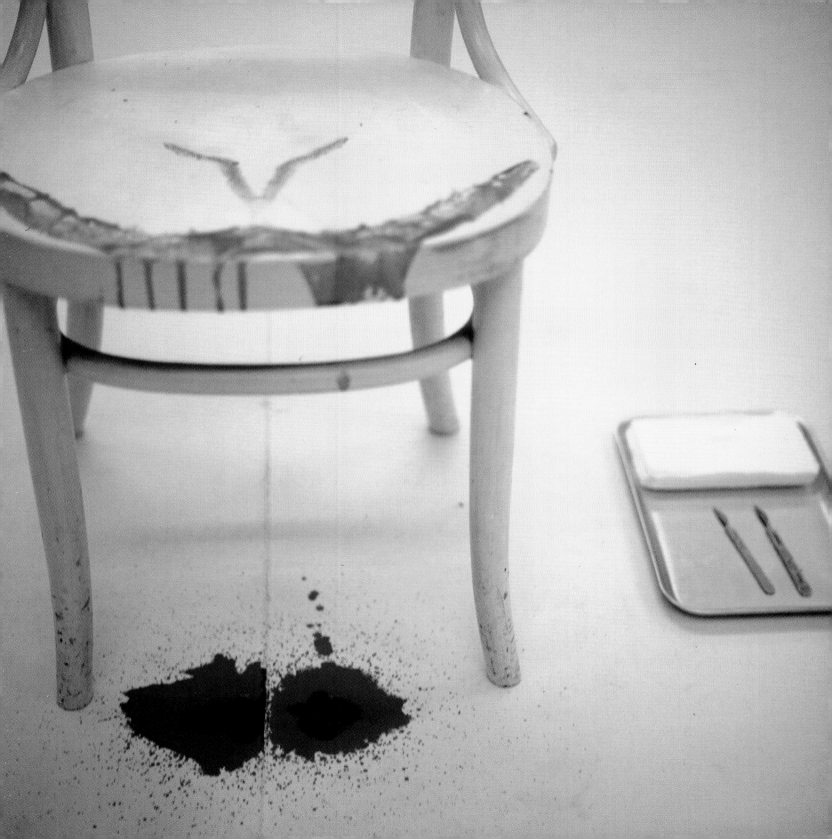

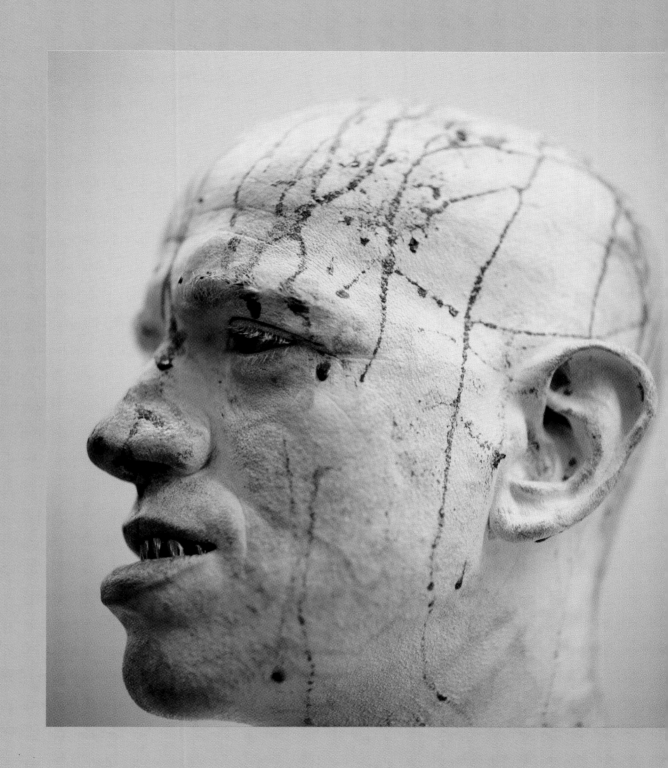

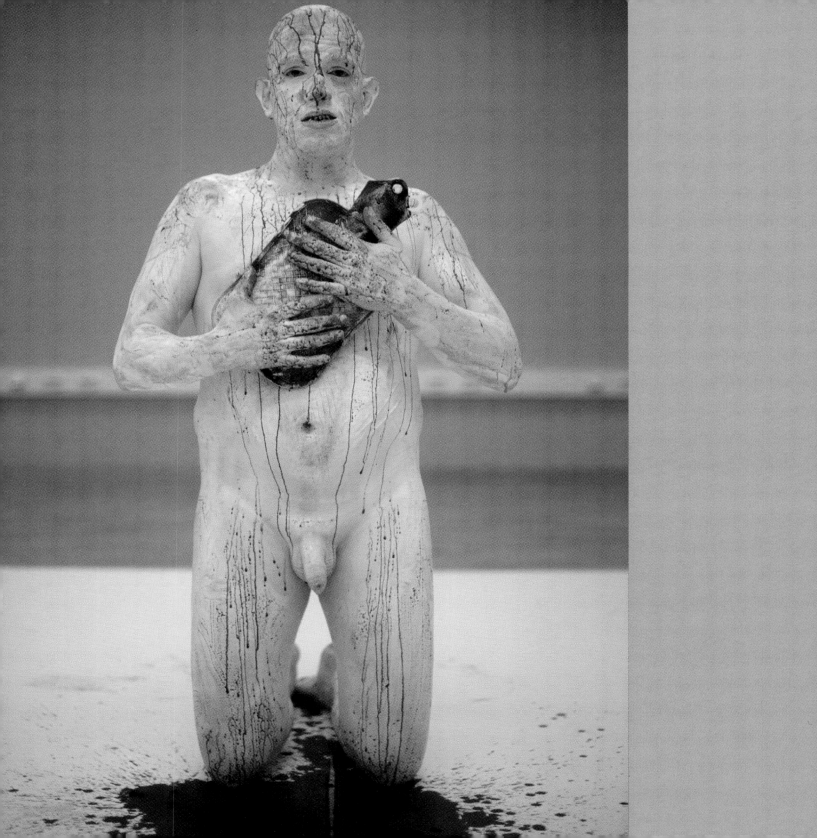

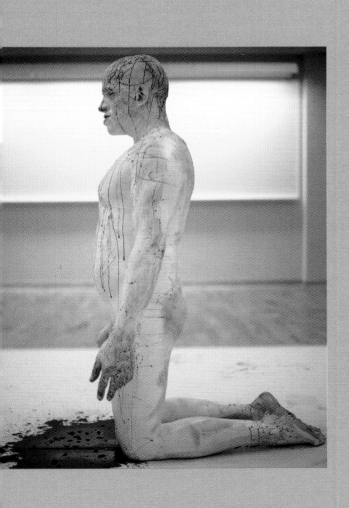

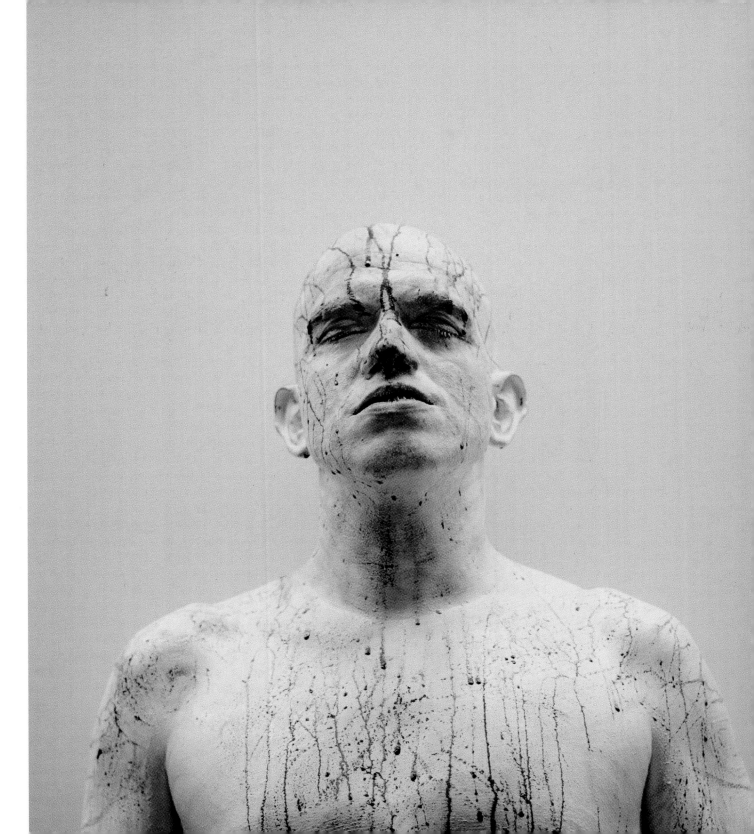

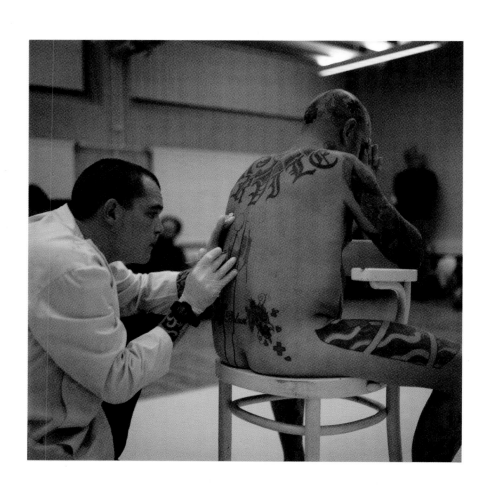

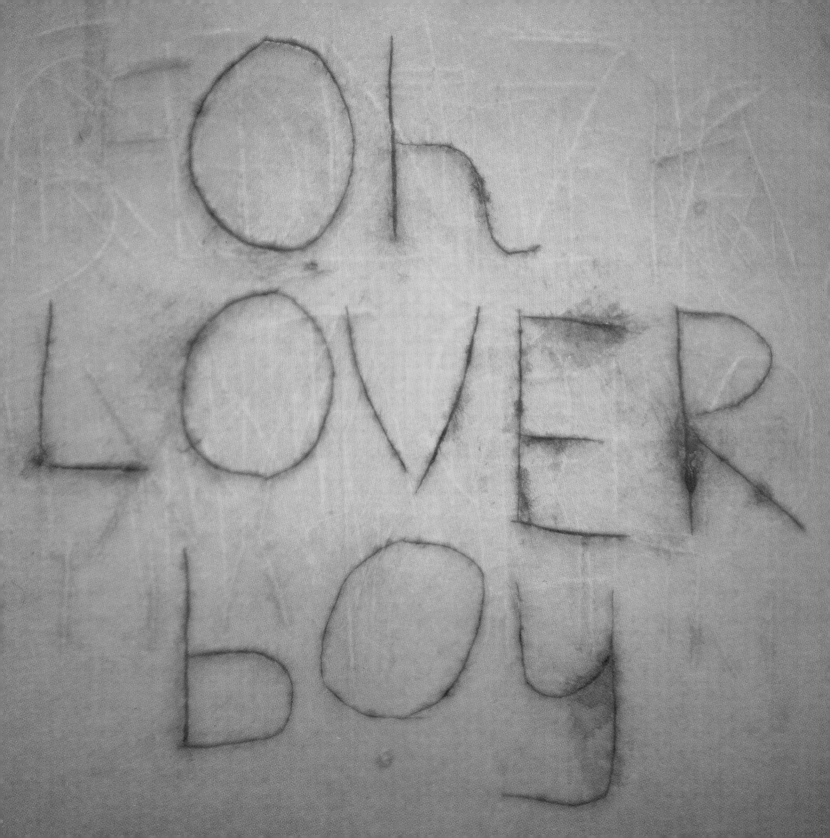

collage

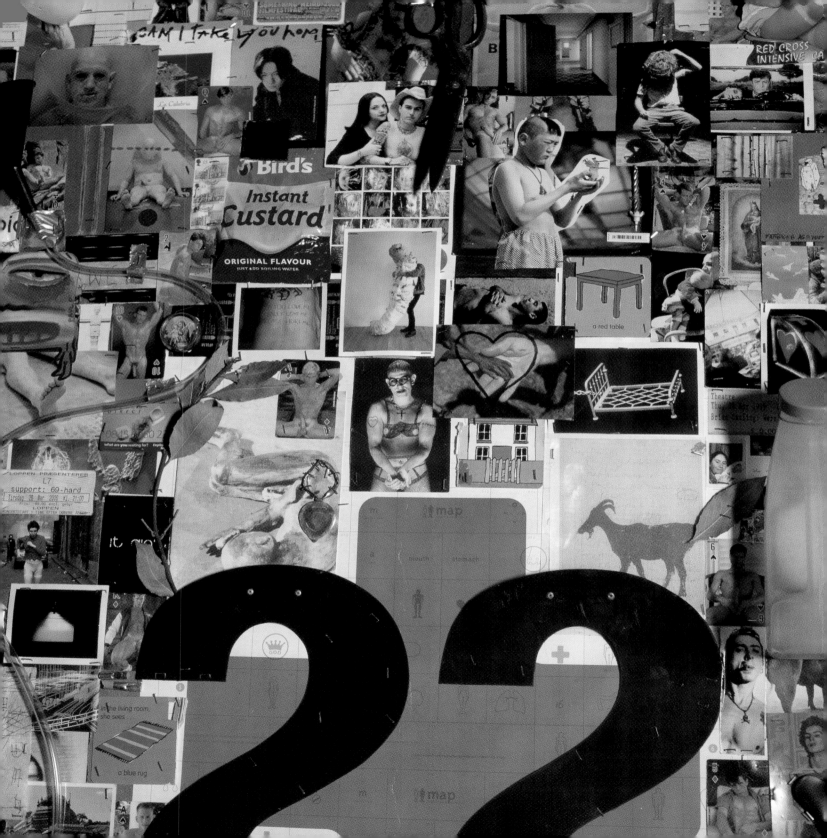

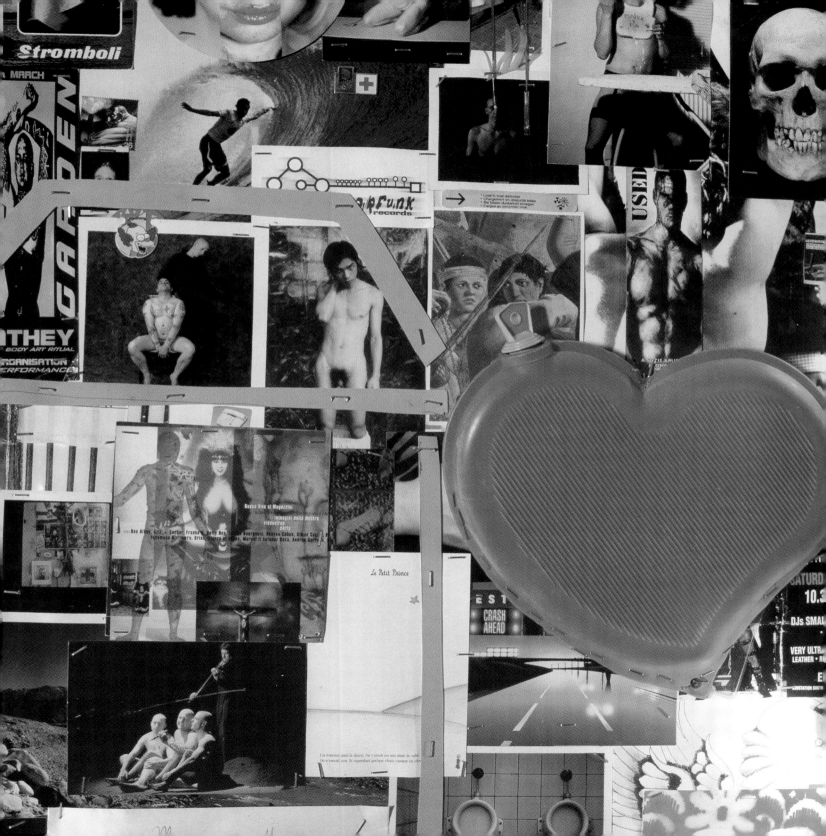

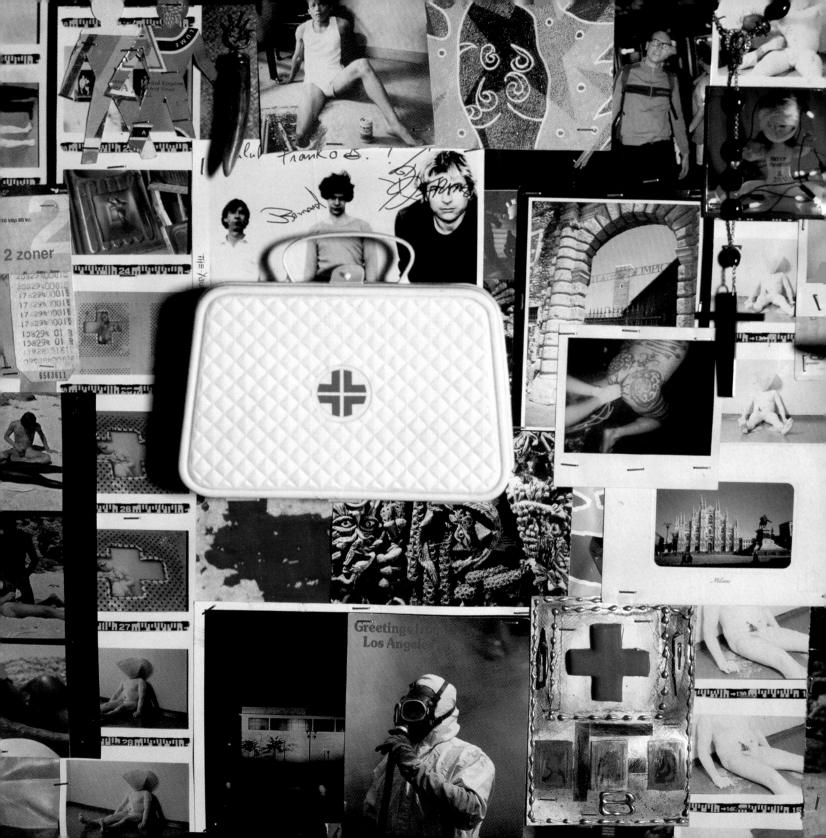

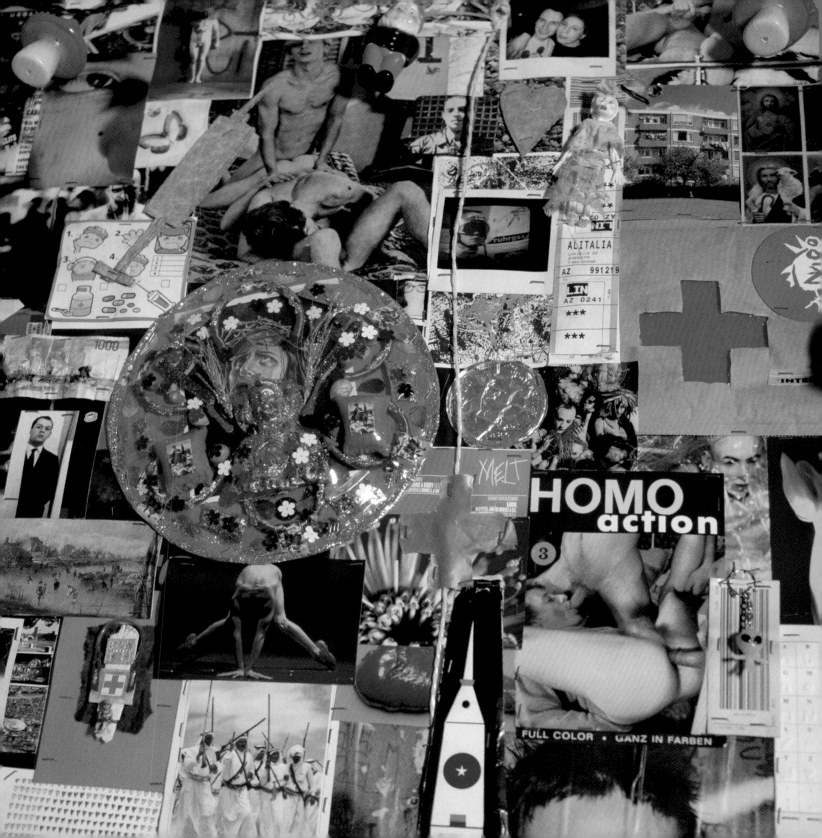

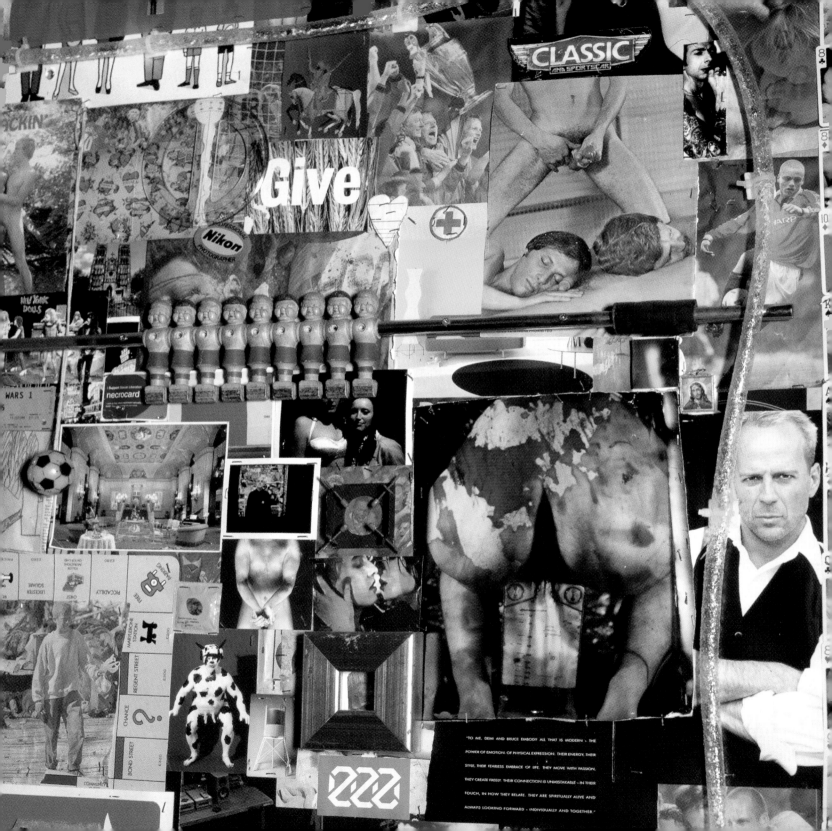

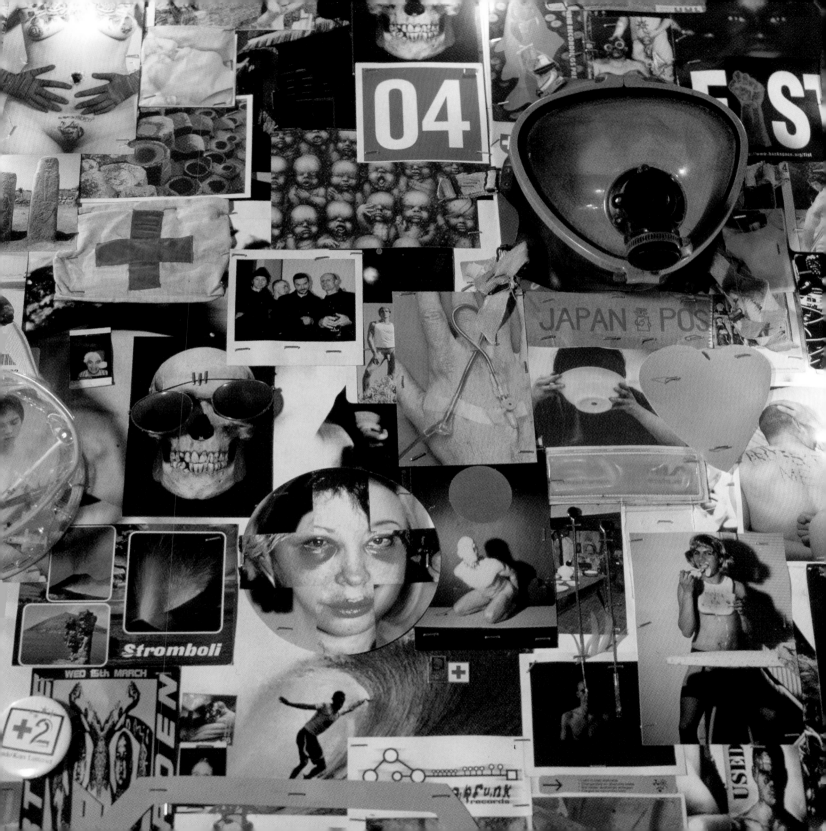

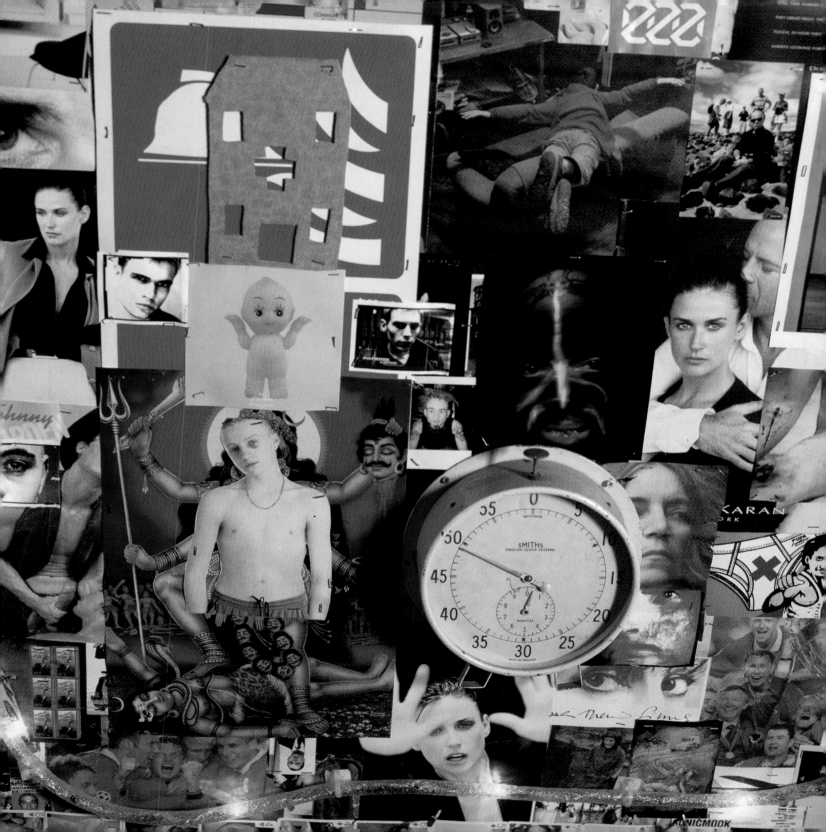

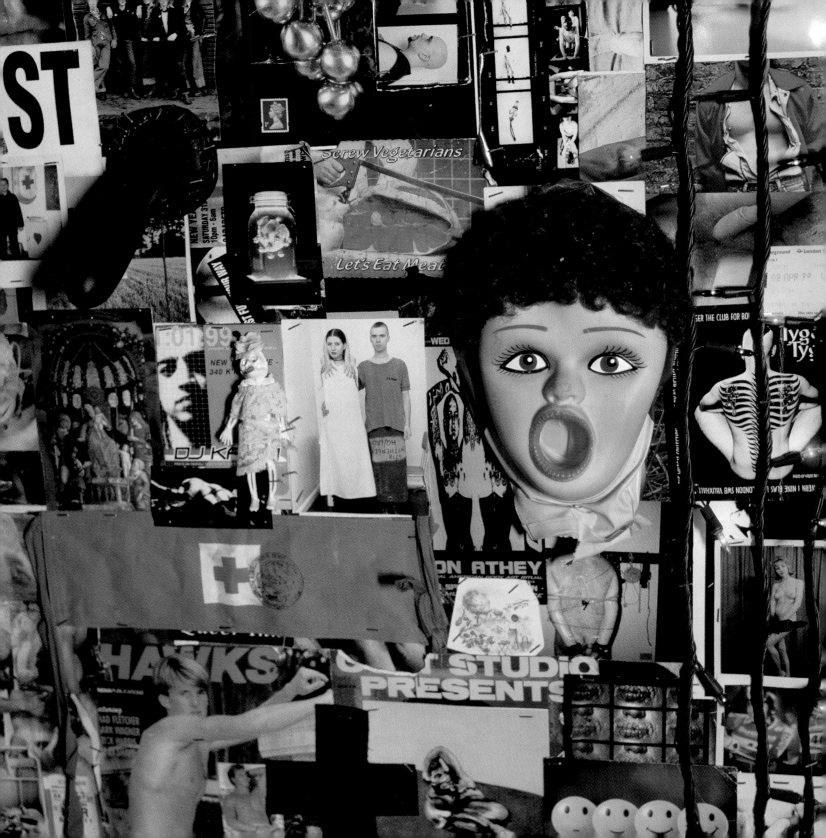

haúte

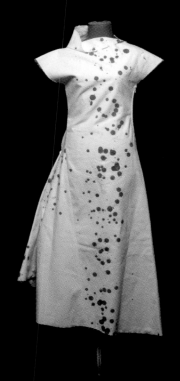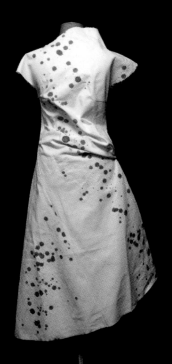

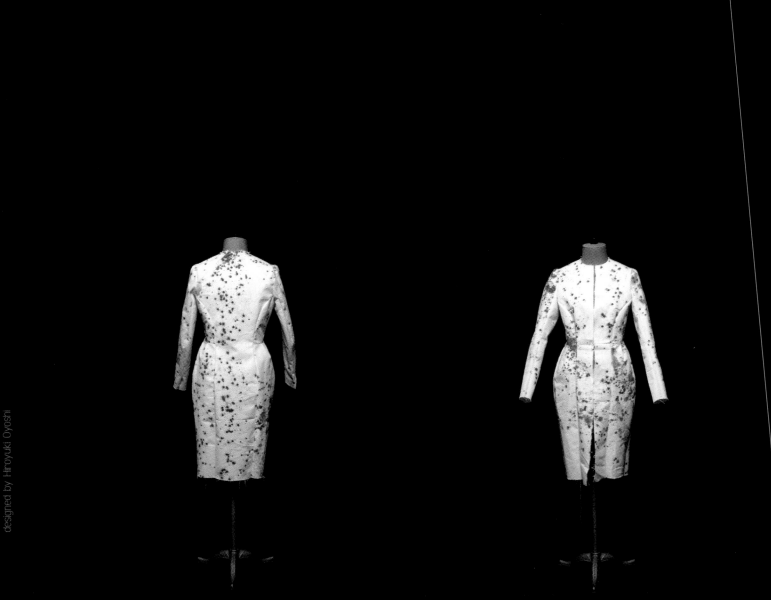

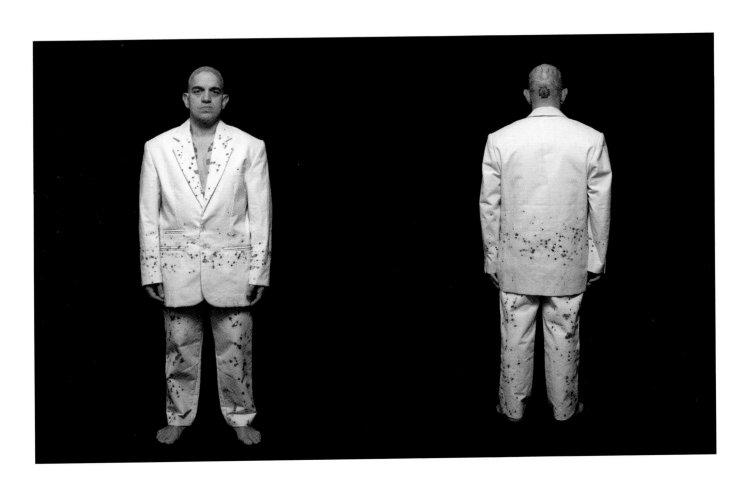

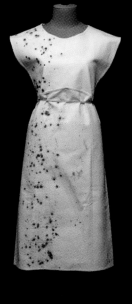

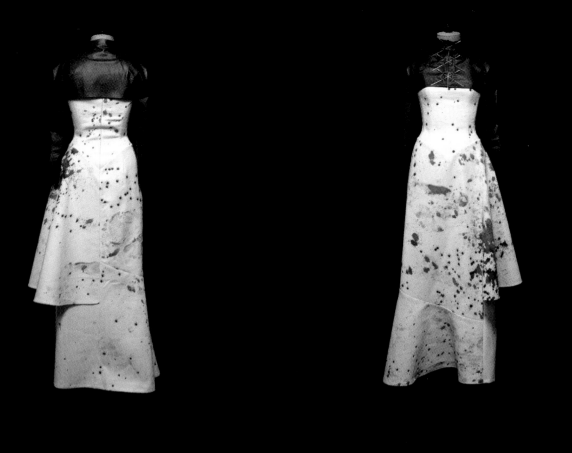

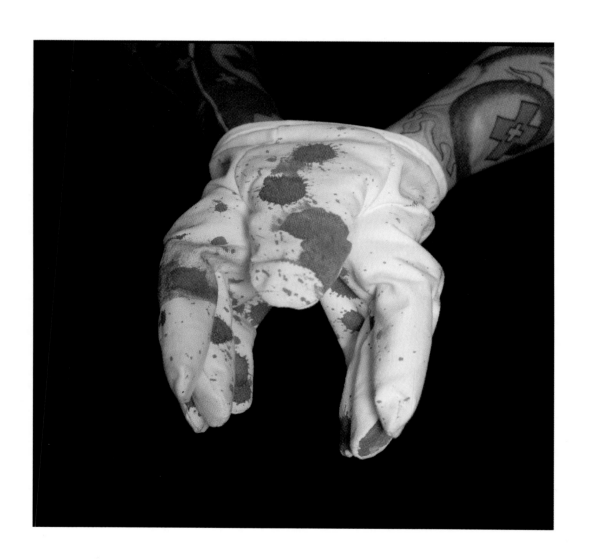

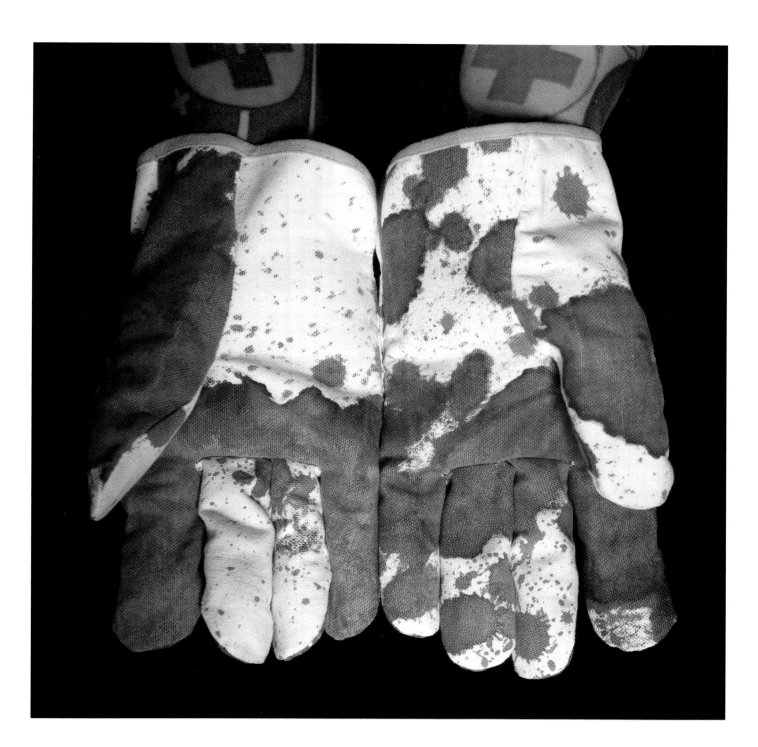

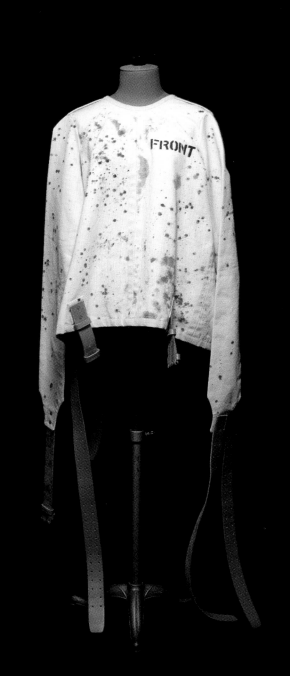

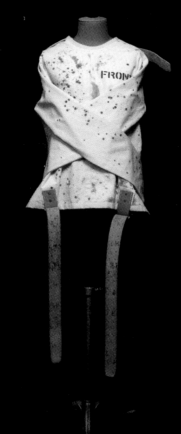

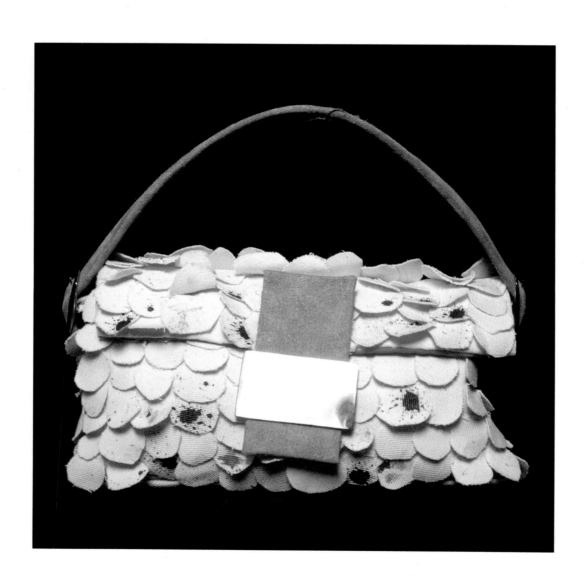

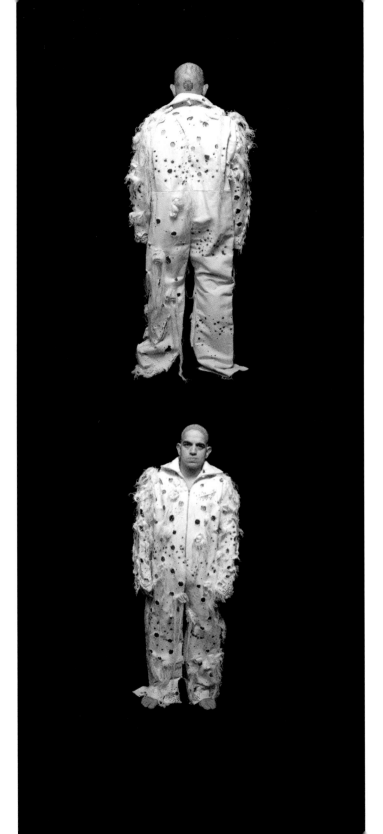

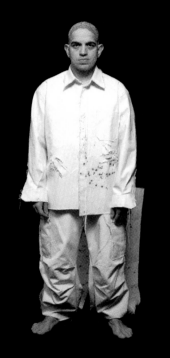

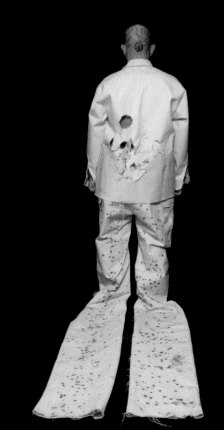

Franko B interviewed by Gray Watson

Gray Watson: You have several times used the same title for different works in entirely different media. For example, as well as being the title of this book, "Oh Lover Boy" was also the title of an exhibition you recently held at the Horse Hospital, a gallery in London, at which you showed collages; and you are planning to use the same title for a forthcoming performance piece. Is that for some specific, conscious reason, or is it just an intuitive thing?

Franko B: I think it is both. It is intuitive in the sense that if there is a title, a name in my head, and I really like it, then I will use it. In the case of "Oh Lover Boy" it represents all the work I do in a way the studio work—and it is just like a little tune in my head. I don't know where it comes from. The collages are very 'pop' and at the same time they have a lot of images of boys or men—porno stars, as well as people I know. So the collages are basically like a diary. They contain things which were either sent to me, or collected personally, or found when traveling—you know, postcards or pictures of boys I have been out with. My new performance is called *Oh Lover Boy*, but the title, in this case, doesn't really tell you about the piece; and this is true with a lot of my work. The titles never really explain what the piece is. Sometimes they have a sense of irony for me, because maybe I know the joke, but they are also very poetic, like *Mama I Can't Sing*. I don't want to describe the new performance too much at this stage except to say that it is a bleeding piece, and it is something between a life class set-up and a kind of post mortem set-up, like in a hospital, where people sit around to hear what the doctor, what the 'expert' says. So in the performance, it's like "Oh lover boy, look what has happened to you."

GW: Look what has happened to you, you have ended up like a sample or something...

FB: No, but it is also a positive thing. It is like people paint you and people look at you, you know...

GW: During the exhibition you also had one evening of films in the gallery in which, again, gay porn featured quite strongly.

FB: They asked me to choose films for a film programme and I came across this arty porno film that was made by a friend of mine in Denmark. He also makes 'straight' art films; which he has been doing for the last 30 years. I also have a lot of other friends who make 'art' films and I had seen some other films I liked, so I got these films together and decided to programme them in with the porno. The porno was quite long and it had different set-ups, each of about 15 minutes—a bit of this, and a bit of S&M.

GW: With Pierre et Gilles type settings, quite humorous.

FB: Yes, so I thought "What a brilliant opportunity to show the art films!" So I showed a short art film, then one section of the porno art film: over two hours six short films were screened with the porno film. It was interesting because to me it was like what the collages do. After a while they kind of blur—what is art and what is porno? And you begin to look at the art films in a different way. It was a very similar structure to the way the collages work.

GW: Yes, I thought so too. I know you don't want to say too much about the performance, but you have written some notes about what you're planning to do. Can we talk about what you said there?

FB: Yes, yes. *Oh Lover Boy* is going to be a performance piece where again, the body is presented: it's there, it's on the table. It is there for you to take, in a way, either to draw or to look at. As I said before, the set-up is going to be like a life drawing class but there's also a clinical side to the piece where you are looking at a body. But the body isn't passive: it's not a dead body. In a way the bleeding affirms life. And this 'body' is looking at you.

GW: I think you said you wanted the room to be both reminiscent of a life room at an art college and an operating theatre used for teaching medical students.

FB: Yes, although that is stretching it a bit, because I am not going to do it in an operating theatre, which would be too medical. It's like a kind of breaching of the two, really. I am trying to suggest that it could be like a medical class where people sit down and look at the body.

GW: So both are teaching situations.

FB: Yes, kind of.

GW: When I first read that you were planning to do that from your notes, obviously I thought about Rembrandt's *Anatomy Lesson*, except of course that there the figure is distinctly dead.

FB: No, I agree, but my work is definitely not about death. You are not coming into a room and seeing a dead body on a metal table, but there will be a certain feeling, you know, as there are going to be people in there, there is going to be the doctor, the guy I work with...

GW: I think you also said that the bed might be a bit between a hospital bed and a sort of stainless steel table in a butcher's shop, which reminds me of Francis Bacon.

FB: Certainly. But like most of my work *Oh Lover Boy* is a painting in itself and a performance where I use the body as a site for representation.

GW: Do you mean by 'site' the fact that it is going to be, as it were, a canvas?

FB: Yes, it is consistent with what I usually say, which is that my body is a canvas. I use the body as a canvas, as a way to make pictures, and *Oh Lover Boy* takes this further. But it is also using paintings like Bacon's as a reference. And this also has to do with the life class situation, with the model in isolation and people gathering around.

GW: The last performance piece of yours which I saw, *I Miss You*, does make a reference to painting, inasmuch as there is a long strip of canvas on the floor, but it also makes a more overt reference to the fashion world.

FB: Yes, in a literal sense but not in a political sense: it is not a comment on the fashion industry at all. It uses the aesthetics of a fashion show in that you have a catwalk, and you have a distinctive white canvas marking out where that catwalk is, and then you have a set-up with people sitting and standing either side

like they do at a fashion show. Here, the difference is that what is being paraded up and down the catwalk is not clothes, it is the body, my bleeding body. So what is happening is that as I walk I am not 'catwalking' but 'painting' the canvas as the blood drips on it. But this is a plus, it's not that I'm painting and I'm trying to do something with that.

GW: You're not doing an Yves Klein?

FB: No, I am not doing an Yves Klein or a Stuart Brisley. No, that is the difference. I am bleeding and I'm walking down this catwalk and the blood is going to go somewhere and it goes on the canvas; and what I do with the canvas later, whether I am going to present it as a painting or I'm going to make a garment out of it, is a different matter. In a way I'm using all the material from the performance, it's like a kind of recycling. I am showing part of the canvas as a painting, and I've asked a friend to make a suit for me, which I am not going to wear but which is to be fitted to my size. I am going to show the suit as a piece of art, a work in its own right.

GW: I was amazed at how regular the drops of blood were on the canvas—presumably because you were walking at a very steady pace. Certainly the main feeling during the piece was the intensity of the thing; it was painful enough seeing you walk slowly once up and down a long catwalk, but then you did it again and again.

FB: Yes, I am parading myself, my body, down the catwalk as many times as I need and can do. You never know whether the performance is going to last two minutes or 14 minutes. I know it has to finish and I know that the maximum I can do is 13 to 14 minutes, which is pushing my luck, but the idea is that every time I come out and start to walk down, you see different details. Yes, I make more marks on the canvas, but also, after the fifth time up and down the catwalk you maybe notice something different.

GW: Was it deliberately planned that you had a whole lot of people taking photographs right at the end? Was that an intended reference to a fashion aesthetic?

FB: Yes, the media were invited; yes, this was a plant; but other people also wanted to come and photograph. So what we did, rather than just let them sit anywhere, was to encourage them to be in a certain spot at the end of the catwalk. But, again, it's the body that is being photographed, it's not clothes for *Elle* or *Cosmopolitan* or *Vogue*.

GW: It did somehow for me—I'm sure everyone reacted differently—make it all the more painful seeing all these cameras flashing.

FB: It was very beautiful. I think, yes, it also reminds me of those machines which you see in certain institutions, maybe in the kitchen, or in outdoor restaurants, where insects are attracted to the light and then electrocuted. It was like dying for me, the model walking down to this flickering light; except I stop.

GW: And you don't get frazzled.

FB: But I like that connection.

GW: The main thing I came away with was the extraordinary intensity it created. The level of concentration on everyone's faces, the seriousness of the occasion. I wondered if at one level you were exorcising demons, and that seemed a very beautiful thing. Then afterwards in the bar you were so cheerful, I remember. It was a completely different you, and all that seriousness went out of the window and you were having a good time.

FB: Of course. You have to remember there is a lot of adrenaline going around after having done a piece. There's the fact that I've done the piece and it went well for me, in the sense that I made a work that I wanted to make without compromising. I didn't have to stop and everything went well. It is also very emotional when I'm making a work. There is this intensity. It's not just me being serious, but I suppose people are... I think there is this energy.

GW: Maybe serious is not the right word.

FB: But then after the performance, you know, I have to wash myself and if I'm happy with the way it went then I'm cheerful.

GW: You once said that you are using language in its purest sense. You create beautiful images...

FB: I try to.

GW: And you said this was a pure way of using language, and that it would be less pure in some way if you were telling stories. Have I got that right?

FB: Yes, it is kind of mixed... maybe a couple of years ago I said that but I feel I am moving on.

GW: Do you think you have changed a lot, as an artist, in recent years?

FB: Of course I've changed, which is good. For example, a couple of years ago I would have said that the important thing is how to survive a performance; I wouldn't say that anymore. For me there is no longer any doubt about how to survive a performance. I can stop it at any time if I need to; and if the performance stops after one minute, that performance can still be successful. There is nothing heroic about what I do. I am not putting my life at risk, that would be foolish. We know now how much I can do, how much blood I can lose, whether I am looking after myself enough and that kind of thing. Of course the amount of time I can perform for in a bleeding piece is limited; but it's the quality not the quantity that counts. If I could bleed for half an hour, what would be the point?

GW: So is the thing about narrative making language less pure something which you don't necessarily feel anymore?

FB: Well, I am still very interested in visual language and I am still very much aware of trying to do things for the right reason and not bombard people with work that is unnecessary, because this then becomes theatre for me.

GW: I have always felt that you were understandably concerned not to have your work interpreted in a reductive way. You don't want overly biographical interpretations of it and you have been very careful to say that it is not specifically gay art. You have tended to deny a sadomasochistic content, though perhaps we can talk about that later—and it depends what you mean by sadomasochism, of course. You have also tended to deny—and I am wondering whether you have changed at all on this—a religious interpretation of your work. I quite understand your point that you don't set yourself up as a guru and I don't think that anybody takes you as a guru. But, on the other hand, you have said you do like going into churches and that you do like depictions of the crucifixion, even though you are now an atheist.

FB: I am not an atheist. I am a non-believer, which is different. I don't believe in God, I don't believe in life after death, and I don't believe that my life is about sacrificing and martyrdom so I can live a better life when I am dead. I was brought up as a Catholic, and after I overthrew that there was a moment, when I was about 19 or 20, when I said "I am an atheist." At that point I used to scorn people who believed in God and I used to think that they were fucked up. But I soon came to realise that I don't have a right to that. I don't have a right to tell somebody else that the God they believe in doesn't exist. So now I say I don't believe; but that doesn't stop me going to church if I want to go, and it doesn't stop me appreciating a beautiful painting of San Sebastian or a crucifixion. Certainly I can enjoy that.

GW: Well it does seem quite related to your work. I am sure, by the way, that you are tolerant of other people's views, but that's another point.

FB: What I am saying is that atheism and non-belief are totally different matters. For me atheism is another fucking religion in the sense that they are actively trying to influence what you believe. They are like Jehovah's Witnesses: it's a kind of vocal thing. "God doesn't exist, God doesn't exist, come on our wagon", you know. I don't say that, I say "I don't believe", which I think is specific enough because I don't stop you believing. I am not saying that your God doesn't exist. There is a difference. I certainly don't believe in what I was taught under a Roman Catholic agenda. But I haven't reacted against it in such a way that I don't appreciate the beautiful images.

GW: And beauty, of course, is not just a matter of how aesthetically pleasing something looks; beauty can stir you very deeply.

FB: I think beauty functions like a bridge, you know, things that touch you. There are many times you are moved and you don't know why. This is something very, very deep.

GW: I think it is good you use that word "touch" because that is in a sense what you want from your own art and what the most genuine art, it seems to me, does do—certainly religious art.

FB: Yes, but I don't know what genuine art is either. I'm not in the business of saying what is genuine. The point is that I don't separate my art from life, because I am influenced by life and in a way life does touch you and there is this thing called art in life.

GW: But there is a way of dealing with life which is quite superficial, which deals just with the everyday and doesn't go deep, and then there is a way of dealing with life which takes you to the most intense moments and the things which really motivate you.

FB: Yes, definitely, but a lot of the time we are not aware when this happens. We can be touched and not be aware. So there has to be a kind of bridging element, whatever that is. My work uses ordinary language because I don't believe that I create any languages: I appropriate language as I read it, am touched by it, am bombarded by it.

GW: You mean the language of the body and the language of these images you are making?

FB: Yes, but also the language that exists, you know, that needs decoding, like when you go into a supermarket.

GW: So you are just using that language to say something, to communicate?

FB: Yes, to bridge in a way...

GW: That's the third time you have used that concept. Bridging from what to what?

FB: Bridging is to make contact, bridging is when somebody else makes a connection with what I do, not necessarily understands what I do, in the sense of "Oh, I understand what your work is about", but when they make contact. For example, a connection is made if somebody writes me an e-mail and tells me about how my work, which they have just been exposed to, has made them think about something that had happened in their life or made them think about themselves. This is bridging.

GW: So it is close to the idea of touching.

FB: Yes, but again it's not about getting what I mean or about the sort of contact you can make with verbal language. You can go anywhere in the fucking world and make connections with anybody and it doesn't matter what background they're from. If people are honest with themselves and open this can happen.

GW: I was thinking recently about something which I'd read ages ago, written by Friedrich Nietzsche: "I admire only what someone has written in their own blood" or something like that, meaning presumably only that which is meant with 100 sincerity, in which they really give their all; and I thought, that is what you want to do in your work, and I found it rather wonderful that you do this so literally. Obviously Nietzsche was using it as a metaphor but you literally do, in a sense, write in your blood.

FB: That's a very nice compliment and yes, to me that connects with what I said about my work having to do with painting. I am somebody who wants to create very beautiful images and I see the images as a sort of painting. Because I am using blood it is very important that I use my blood. It's not theatre, you know, it's not fake blood. I have also said this before, a long time ago, that I never thought of using animal blood as a way to represent blood. I could not have a relationship with that; and it wouldn't have made

sense for me to do that if I wanted to represent a body that was given life through blood or a body that was a canvas and the blood paint.

GW: I find it slightly hard to understand what that's got to do with painting but I can absolutely see what it's got to do with being 100 sincere and giving and making a bridge to another person.

FB: I think in a peculiar way, I connect because I paint. When I am performing, I am also painting. Again I'm not painting like Yves Klein or Stuart Brisley, I'm not interested in that; but then at the end, if the body is a canvas, the blood is paint.

GW: Yes, but that is still talking about the medium and I am having difficulty understanding why you care so much about the medium.

FB: When I go into a museum and I see a beautiful painting, that's the nearest thing I can think of to what I want my work to be able to do: to create that, but in life—I mean creating a very beautiful image with the difference that people can smell and also touch it.

GW: I think I see. So in a sense these things are models to you, successful examples of what you're aiming at?

FB: Yes, certainly. When I see a work by Bacon or Rothko for me these are amazing paintings... a bridge that touches you. With *Oh Lover Boy*, when I was talking about the work in advance to the people that I was having to convince to help finance it, I explained it as a painting for me: this one looks like a Bacon.

GW: I suppose it's a point of reference.

FB: Are you saying "Why don't you paint?"

GW: No, I'm not saying that at all. It's more that I'm wondering why you want to insist on that connection so much.

FB: Because there is such a snobbery around art, about what is a painting and what is not a painting. I think there is that, you know, and in a way I think a musician like Miles Davis could say, if he wanted to, he could say he was fucking painting with sound, it doesn't matter. I don't know if there is an example.

GW: One thing that interests me a lot is that art is often thought of—and I think quite rightly—in terms of a gift. I don't mean that in the sense of the artist having a gift or a talent, I mean it in the sense of art being a gift given by the artist to the spectator. And you seem to me to be someone who very much gives.

FB: Yes, in a way I give and I know what you are saying. I think as artists—and not just as artists, as human beings, because we are talking about life here—we have got to give, because otherwise we are taking all the time. I am touched when people say my work gives them something; and then in a way their coming to me and giving their time and their trust, for whatever reason or whatever their agenda is,

is giving to me and is also making me exist in a way. Then I feel that, whatever relationship we have, it is a kind of give and take, it has to be.

GW: I suppose my thought about your art being very much to do with giving first arose when I was thinking about you in comparison with Hermann Nitsch and the fact that he is using animals' blood while, as you were saying a moment ago, you are using your own blood—there is a sense in which it is a purer gift if you are giving your own blood... just using yourself.

FB: Yes, I agree. But it is not just giving it on that level and this is where the bridging comes in—touching people. I think on that level...

GW: I only meant that as a metaphor.

FB: No, but you have to be careful. Otherwise it becomes like this kind of offering thing, it's like a scenario where you are sacrificing, which is not what I am doing. I am not interested in that.

GW: This an important distinction.

FB: Yes, because I am not here to give, I am not a saviour, I am not a cheap Jesus, I am not here to save the world. Essentially I am an artist and like all human beings artists are really selfish: it's about ourselves. But if, rather than just take, we can also give with that, then for me it is a plus.

GW: A great many people do think that your work gives. But for me it partly does so precisely because it refers to the fact that an awful lot of human relations do involve just taking, exploiting, exertions of power in quite a negative sense—because it refers to the cruelty which exists in society—and I know you have sometimes said that that's where the real sadomasochism lies, not in bedroom games.

FB: Yes, for me S&M as an issue in society is about people keeping their kind of role play. It's about power in the kind of role model that people take, perhaps in order to be able to survive life as they see it. So in a way, yes, to me this is S&M. When people talk to me about the flavour they like in terms of their sexual fantasy, that's fine, but I don't think it's a big deal, I have to say. I'm not quite sure what you are asking me: are you asking me whether I am a sexual sadomasochist?

GW: I certainly wouldn't ask such a question. (laughter) What I was asking you was more about channeling. To me part of the value of sexual sadomasochism is that it is a way—and at the very least a harmless way—of channeling some quite negative emotions.

FB: Yes.

GW: And I suppose what I particularly value in art like Francis Bacon's and your own is that it not only channels this negative material in a harmless way, like bedroom games might, but actually it does a bit more than that: it helps work it through in some way, because it puts it into a public sphere.

FB: That is cathartic?

GW: Partly; but not only that. It also helps one to come to terms with, and reflect more deeply on, these things which have the potential to result in very negative behaviour. You have said that you want to "make the unbearable, bearable".

FB: Yes, but you seem to be saying that people who do practice this kind of sexual behaviour are better people than those who don't.

GW: Not exactly, but I can see that what I said might have that implication. And you mean there is not the slightest connection really?

FB: I think it's bollocks, of course it is. I mean, if two people want to act their fantasy out by one kicking the shit out of the other, it could come out as a positive thing rather than then being a total negative thing, if both really liked that. But what I'm saying is, to me, that is a game; and we are talking here about situations where people actually kick people, or keep people down every day in the way that they behave, or use whatever little power they have over someone else.

GW: Sure, I understand that. And more specifically, what I am talking about is art being able to deal with this, clearly, very problematic side of life. You are saying that sexual games may or may not deal with it, and you're probably right. But, more importantly, I am proposing that art does deal with it.

FB: Of course it does, art deals with a lot of aspects. This, I think, is why people are touched by art.

GW: I am thinking about a valid way of dealing with these very difficult negative feelings in life—feelings which might normally result in people being vile to each other—but which, through people being touched as we've agreed they can be by art and perhaps gaining some understanding, maybe needn't result in shitty behaviour any more.

FB: I don't know, I really don't know.

GW: For me, work like yours helps one deal with these things.

FB: But it doesn't help everyone. Some people get really upset, or just think "O God, he's kinky", or say "What the fuck is this about?". Once somebody shouted to the people who were photographing me "You stupid photographers, why don't you photograph your girlfriend? She bleeds every month".

GW: Probably that person wasn't touched or, if they were, they weren't happy to accept it in some way.

FB: Yes, of course, everyone has their agenda, that's fine. He wasn't impressed, which is fine.

GW: Well, perhaps I am not going to be able to push you much further on this point. I suppose what was also in the back of my mind was Pasolini's last film *Salo*, which does seem to me a very political film. It is about how these negative feelings can take on political and social forms, and I think he is trying to understand that and its connections with sexual perversions—and with art.

FB: Yes, and he is also not very kind to the subject.

GW: [laughs]

FB: I don't mean physically, I mean how he deals with power. He's not kind to the state, he's not kind to the church. I think it is a good film but, I must say, I find *Salo* too much for my taste.

GW: Your approach is a slightly more gentle and tolerant one, are you saying?

FB: I don't know about tolerant; but maybe, yes. I don't like violence. It's bizarre, you know: I don't like violence. Yes, it is interesting. This is one I haven't got my head around... I don't like violence, at all.

GW: I read something recently about you "allowing all possible details to happen". I wondered if you could say a bit about that... I suppose it is part of your working method?

FB: Yes, this is a kind of philosophy I have. In a way it's quite similar to what we touched on earlier about the language thing: saying less is saying more; the more pure you are, the more you say. And in a way by "allowing all possible things to happen" what I mean is to look at the details and also to go for it. To me, it means to be open and not to close yourself down. And this applies not just to me as a performance artist or me as somebody giving out, but also when I am receiving, whether as a spectator or just as a human being out there. There are a lot of things that can happen. In my work, you know, everything is possible in terms of how people read it. There is not this kind of "oh no, oh no, you got it wrong". I might say "I don't subscribe to that", but that's different. It's like us both looking at this pen and, yes, it's a pen and it's got a black line in it, and we agree on that; and then you say "it's got a warm feeling" and I say "well, I think it's got a cold feeling". Do you know what I am trying to get at?

GW: Yes, I think so; but now you seem to be putting quite a bit of emphasis on how people see your performances, whereas in what you said earlier about letting all possible details happen, I thought you were referring particularly to what actually happens in the performance.

FB: I suppose, yes. This is why in a way I have to go with things that happen while I am doing...

GW: Unless some audience member does something funny, you pretty much know what you're going to do in advance, don't you?

FB: Not emotionally.

GW: How will the emotions change what happens?

FB: I can change, and the one you saw was very... the emotional side was very hard going for me. I thought I was too emotional.

GW: Do you mean *I Miss You*—the one done in London at Beaconsfield?

FB: Yes, and in the one I did in Birmingham I was more in control; and there was a moment where I felt angry and I felt I wasn't going to take any kind of shit.

GW: Is that because the local newspapers had been so tiresome shortly before about it?

FB: I don't really know; but in London it was more emotional. I think for me it was a better performance, and it was a better piece because more things were able to come out, because, yes, I was naked, I was totally naked.

GW: Obviously you mean that not literally and physically, but really. Certainly that's what it felt like—it felt absolutely 100 there.

FB: Definitely, I think it was. But how it happens, you don't know; because you cannot say "I am going to be 100 and I am going to really, really give".

GW: You may not be in a mood to do that when it comes to it.

FB: No, you may not. But I think the most important thing is that you are honest in what you are doing. That's why I am totally naked and, as you said, we aren't talking about literally. It means to be really kind of... it is to give, it's to really give. But it is difficult because it's a state and you can't just tune into it. You know when you are doing it, you know if it is working, but you don't know how you are doing it. But you do know when, yes, this is really it.

GW: That must be a lovely feeling.

FB: It is a lovely feeling, but it is also emotional and it makes me cry. That has happened. Yes. So that, in a way, is what I mean: for me to allow all the possibilities to happen, but also you can talk about this from the point of view of the person looking—to kind of allow that.

GW: Because in a sense the same sort of open attitude is needed on the spectator's part?

FB: Yes, I think so; but I don't know how you do that. It's hard to achieve. But this can also kick in later on, maybe three months later or the day after, or when you are going to bed with an image in your head—and you realise that you missed a detail, you realise that maybe you reacted too quickly, that you perhaps came to a conclusion too fast, that you presumed... you know.

GW: Then you re-visit those things... A thought popped into my head, which is slightly tangential to what you were saying: there are ways of touching people, aren't there? A cult leader can touch people, but it is quite a destructive form of touching. .

FB: Yes, I agree.

GW: And do you feel in a way that your images are healing images for people, or do you think that too presumptuous a statement?

FB: I don't know about healing, because I don't see myself as a guru.

GW: In the sense that perhaps Joseph Beuys did, for example?

FB: Yes, maybe. I don't think that role is appropriate for me; and I feel this is what I meant before about bridging. I believe that when looking somebody in the eyes or just being in the same space with somebody and feeling a certain energy—you don't need to talk—you can see it, you can see in their eyes that in a way you are giving something, something which they will maybe want to hold for a while as a nice experience in their life, for whatever reason. I think that is nice, but I don't think my work is about healing. But if somebody said to me "since I have seen you, my life has changed more positively", I think—and this is crazy—I would believe them.

GW: It is a very individual thing.

FB: Yes, I think it is a personal thing, but in a way I would rather people didn't tell me this, because I think it is very awkward... because I don't want to have that kind of power—you know what I mean?—where I actually believed I could change things and that my work could bring another dimension to somebody's life. What I hope that my work can do is bring something else in, and maybe then they can connect. But by connecting it doesn't mean they have to subscribe to it. My work is not about telling a story: it's there. And the point is, as I said earlier about the selfishness of artists, we do it for ourselves first. Whatever you do, whether you're an artist, whether you're an accountant, whether you make furniture or bread, or whether you are self-employed or you are paid by somebody, you are doing it for yourself. For whatever reason, whether it be economic, practical, to be able to feed ourselves...

GW: Emotional.

FB: Emotional... and of course the bread you make, if I buy it and it's nice, I would say "I will come back tomorrow because that bread is brilliant" and you would feel "Oh, I touched him, he wouldn't come back otherwise". So in a way it is the same. People consume my work, I get paid for what I do and that allows me to be independent. What I do in my life is a strategy in terms of allowing me to be me, whatever that means, and allows me to exist with a certain amount of things which I feel I need to have, like feeling independent, having a kind of integrity and being happy—much like everyone else. Of course on the surface different people seem to want very different things but essentially I think the roots of why people want the things they do are not that different. Our basic needs are pretty much the same; it has a lot to do with our wanting to feel adequate as human beings. And I think essentially we are doing it for ourselves. I don't believe in the artist as...

GW: Sacrificial victim?

FB: Or "I am doing it for the whole world" and the healing... no, no, no.

GW: You like making those bridges yourself; it's a pleasure to you.

FB: Yes, of course it starts with me. My prerogative is to make works which I feel can also give me normal material things; but also the human element to me is very important. Maybe for some people the human element is not that important, because they get their fill somewhere else. That's fine, you know, and I think it is just another way of existing. Some people might say that basically I am too primitive—the messages are too simple and primitive—and they prefer to do things in a way which seems to me kind of mechanical.

GW: Intellectually thought out.

FB: Yes, you can call it postmodern, you can call it whatever you want. It either works for you or it doesn't. The main thing for me is that my work is not about being clever. I don't want to do things that are 'clever', I want to do things that mean something to me. But there is that kind of scorn; I remember when I was at college some lecturers and some students, who were reading all these books, would look at people like me as being kind of naive or too basic or too literal. So what do you do? I don't care. In a way if I had to choose, I would like to be considered naive because I feel that you can learn more by being naXve... by being open.

GW: I was just wondering, as we were talking about touching and building bridges and the personal nature of communication, whether we should just talk briefly, before we end, about your one-to-one performance, where you were available for two minutes per person, where everyone had their little time slot to be alone with you and then whatever happened, happened. And could you also say why you titled it Aktion 398?

FB: The word "Aktion", with the German spelling, is a tribute to the Viennese Aktionists, Brus, Muehl, Nitsch and Schwarzkogler; the number is just chosen at random. The idea of the piece is that you come into the space, you come with your baggage into the space, and you find me: I am there naked, painted white with a little wound in my belly with this plastic collar that you put on pets so they cannot lick themselves, and that is a kind of metaphor for our wounds as a human being, the wounds that we can acquire and suffer to get to this stage where we are now. Some people filmed me and some people told me "I understand what you are trying to do." But with some people, I look at them and I know, I know that they know what I am showing, and either they are grateful for that or not. Some people think "yes fine, big deal" and some feel very moved: they feel touched in a way or they feel they are glad they came. But that piece is a difficult one, because usually we try to avoid such situations in life and cannot face being confronted with our wounds. Also it is a difficult one because, although this is an encounter and I like to see it as a collaboration, in a way I am the one that has more power because I am the one who set it up. In terms of being vulnerable, I think we are both vulnerable in more than one way; it is not just me because I am naked. They are vulnerable, too.

GW: I think a lot of people thought they could easily make a fool of themselves; embarrassment is always a possibility.

FB: But I am quite happy with the person who doesn't move at all and just kind of looks at you but you can tell there is something going on. And in a way I don't want to know what has gone on for them and I don't ask them what it is that this has done for them. I think it is a personal thing. I really like that piece because I will never know, with the 150 people or 200 people that I see in one day, what impact I had on them. It is not about asking them. I have seen now, perhaps, a couple of thousand people on that basis for two minutes. It is amazing to try to remember everyone; then there is this magic moment, this moment I remember from Italy, or this moment I remember from Mexico—and that's life.

Franko B:
Haute Surveillance,
Haute Couture
Sarah Wilson

I have only a face of wax and I am an orphan
And yet wherever I go angels come
To show me the path of that strange Father
Whose heart is softer than a human father's heart

…

I am he who can dissolve the terror
Of being a man and going among the dead.
For is not my body the miraculous ash
Whose earth is the voice of the speaking dead?

Antonin Artaud, *Saint Francis of Assisi* [1]

Haute Surveillance

Tough and gentle, ugly and radiant, Franko B transforms cruelty into beauty, contempt into love; he has turned his story of abuse and institutionalisation, from orphanage to art school, into a parable of creativity. His current performances become an arena of encounter: the exploration of self and others. Like a latter-day Jean Genet, Franko generates a tension between the abject, the everyday and high culture; his hybridity constitutes an essential part of his message.

Franko's first seven years were spent in an orphanage in Brescia, in northern Italy run by priests; he returned to his mother for the next three years in a small town near Novara; again he found himself sent away, this time to an institution run by the Red Cross, not far from the Lake Mergozzo. In the summer of 1973, while staying in a Red Cross holiday camp at Marina di Massa near Carrara in Tuscany, he went on a trip to Florence. Here, for the first time he was taken to the Uffizi and discovered the madonnas, angels and demons of the Florentine churches: Saint Francis, Saint Sebastian, the repentant Magdalene—transfigurations and torments, depictions of life, death and martyrdom—just as Genet had discovered the possibilities of literature—Ronsard, Racine, Corneille and Victor Hugo—in his prison libraries. Franko's life-changing confrontation with painting and sculpture would be intellectually consolidated only much later, in England, when he was in his early twenties.

Genet's story was that of the illegitimate, adopted, changeling boy, who created a universe of homoerotic love and meaning out of the degradation of his prison experiences. "Genet had been measured… throughout his life; (his body was virtually an official document, as much a record as his accumulated crimes and sentences)." [2] The relationship was constant between Genet's changing image and official control. *Haute Surveillance* was the title of a play of 1947. [3] Surveillance was essential to his 'reform'—from the panopticon structure of the Petite Roquette jail, to criminal mug shots; his *Thief's Journal*, specifically describes two mug shots taken at sixteen and thirty years old. Franko was similarly inspected and

controlled. His body, inscribed with multiple signs of the red cross, with his loves and his scars, is also a record through time. His skin bears witness to his past, while functioning apotropaically—as a protective and defensive organ—and as an invitation to a certain kind of lover, a certain kind of love, in the present.

The Burning Chapel

We descend through swing doors into Franko's studio: a basement space in Toynbee Hall, the haunt of lost souls and Victorian philanthropists, the purlieus of Jack the Ripper, John Profumo's territory of rehabilitation after the great political scandal of 1966. The Establishment descending to the tart; compare Franko's double portrait of himself, tattooed, naked, beatific and Melvyn Bragg stiff-necked, suited, self-confident. The two men are surrounded by anonymous male beefsteak playing cards–the Queen of Spades, the Ace of Diamonds, the wanking Seven of Clubs.... Here, the 'liberal' English Arts establishment sees only sex, naked bodies, issues of decency or censorship. The collage is called *Mr Disclaimer and I (with friends)*, the preposterous Lord Bragg as "Mr Disclaimer" has all the resonances of a Peter or a Doubting Thomas. Bragg posed with Franko for these photos—then distanced himself from the 1998 South Bank Show, *Body Art*, in which Franko participated along with Fakir Musafar, Orlan and Ron Athey, and which Bragg, himself, had commissioned.

Franko's studio and his flat in Waterloo form a continuum: two complementary environments within his personal 'torture garden'. [4] In the flat, perforated metal screens are cut with the letters TAKE; filing cabinets are branded with red crosses, a car door hangs on a wall, cut, again, with the cross—all these rejects are transformed, burnt through with an oxyacetylene torch, into things of beauty. A red and white bus stop shouts REQUEST, next to a display of crucifixes and colostomy bag reliquaries hung on the wall. Rubber gear, anal jewels, diaphanous jelly nozzles and pricks from sex shops are offered like sweets: the paraphernalia of ecstasy. There is an overwhelming presence of flesh, everywhere "postcards or pictures of some of the boys I went out with", the porn shots, rent boy posters, Franko's fabulously erotic pinball machines, topped with plaster saints. There are pin-boards of changing collages, where a gape-mouthed sex doll encounters Titian's *Sacred and Profane Love*, Indian gods with giant erections are measured against cut-out shots from *Homo action*, photos of Franko's performance art friends, Stelarc, Orlan, Ron Athey and Annie Sprinkle confront the inane grin of a Smiley badge. Again, one recalls Genet: *Our Lady of the Flowers* begins with the extraordinary scene of the *chapelle ardente*, the chapel burning with the fires of love. On the walls, photographs of beautiful men and boys form a shrine of faces torn from illustrated papers, representing the now decapitated, guillotined heads of the previous inhabitants of Genet's prison cell, where, as he says: "I raised egoistic masturbation to the dignity of a cult." [5]

In Franko's apartment, and studio, there are also the signs of hospital and operating theatre: a prosthetic universe—wheelchair, crutches and callipers—used in performance actions and photographs which were staged in concrete underpasses, in homeless London's 'Cardboard City': a vocabulary of poverty, spiritual deprivation, blockage and impotence made visible through excess. And everywhere there is the red cross

left: Red Cross Institution, near Lake Mergozzo, Italy. Photo Franko B
right: *Mr Disclaimer and I (with friends)*, 1998. Photo South Bank Show. Collage Franko B

or the heart, not only cut through metal but gouged into desktops, children's chair seats, the twin pushchair, the grubby pair of trainers, yellow wellingtons—or the tragic pair of baby's boots. "You can turn anything into an icon which can be religious" Franko declares.

Franko's titles: *Blinded by Love*, *I Miss You*, *I'm Not Your Babe*, *When I Grow Up I Want to be Beautiful*, *Protect Me*, all imply the child alone, the artist alone, inventing icons to be adored, inventing strategies of a deflective love, a love that ultimately repels or mutilates its objects—a love that cannot be endured or cannot be sustained?

The Heart and the Cross

Aiutare e aiutarsi, to help and be helped. Franko's universe is a universe of caritas, the caring and protecting love which combines the heart with the Red Cross motto in Italian. "I don't believe in a blood-related family... Love has to be a big thing" says Franko, who at one time was a blood donor. He also worked for Age Concern as a punk-haired volunteer, favourite of the Lambeth grannies... Love, art, escape and survival are inextricably linked, beginning with Franko's first paintings as a child—mystifying his instructors—tree trunks in red. To escape his institutionalised predicament meant becoming a man, and leaving his country. To avoid military service was an imperative, and Franko found himself travelling through France, reaching England and getting to London. A period of poverty and experimentation led, at one stage to hospitalisation and Franko's determination, at this point, to make something out of his life. In Thatcher's London, Franko became an anarchist punk, attending meetings and discussions before the homophobia of various groups discouraged him. A casual suggestion that he take up pottery classes in Brixton (he made small male figures, rather than bowls) led to his admission to Camberwell School of Art's foundation course. He moved to painting, and at last managed to be admitted to Chelsea School of Art. Even more inspirational than the Fine Art teachers, perhaps, was the encouragement of the librarian: Susan Sontag's *Under the Sign of Saturn* and Foucault's *Discipline and Punish*, for example, offered new frameworks and structures of thought that would rapidly feed into his work.

But intellectual perspectives onto his past or creative present never detracted from the directness and the simple universals of Franko's world—a directness that continues today. The series *I Miss You*, shown last year at the Wellcome Institute, transformed motifs first generated as sketchy drawings on 'wound wipe' tissues, into rough carvings on wooden panels. Red painted figures, the heart and the cross, accompany a series of other images: a desultory house, a cruciform window, an ambulance, a male figure, vertical, horizontal or in a doubled configuration. As was said of Henri Matisse's crudely graffitied *Stations of the Cross*, "These violent signs suffice me: they tell me the essential story. Why should I need anything else?" [6] Franko provides a conflated narrative of love, encounter, security, loss, and death.

I work in, across and between the mediums of sculpture, installation, performance, photography and video. I create objects, images and actions that both focus on and frame my raw and exposed body.

Much of my work presents the body in its most carnal, existential and essential state, confronting us with the essence of the human condition in an objectified, vulnerable and yet seductively powerful form. My concern is to make the unbearable bearable and to provoke the viewer to reconsider our collective understandings of beauty and suffering.

In my most recent sculptural work I have been continuing to manipulate found objects, but have been concentrating more on developing an iconography of seemingly everyday images and symbols within them. [7]

Mysteries of the Wound

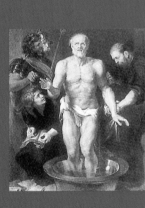

The signs of heart and cross blossoming everywhere, in Franko's studio and on his skin, have not merely appeared like miraculous stigmata. Burned in, cut in, the shiny red inserted with perspex sheets or thickly painted, each edge surrounded by a scar-like crust of metal or frayed edged of cloth... these are also wounds. They signify, literally, the making vulnerable of any object: wounds which at once pain and say "Protect me".

Franko's earthly family of friends, lovers, artists, is complemented by a spiritual family. Nearer in time to us than his ancestors, the great Italian religious artists or the Flemish masters (I think here especially of Ruben's standing, bleeding male—*The Death of Seneca*), two figures are especially important—both encountered while Franko was at art school in London. The first is Francis Bacon, a painter of extremes, of screaming human existences trapped within the furnitures of modernity, of passionate couplings in claustrophobic spaces, of lurid oranges and blacks, of red and purple bodies opened to blood, bone and gristle. A painter with old master aspirations; a painter of religious triptychs in godforsaken times; a homosexual, contemporary artist and humanist. The second is the Italo-French performance artist of the 1960s and 70s, Gina Pane, whose work Franko discovered as a student in Lea Virgine's book *Body Art*, in the library at Chelsea. In Gina Pane's remarkable sculptures and actions, both physical objects and the artist's body are governed by an aesthetic of the blade and the wound. In 1990, Franko made a video of someone cutting "Democracy" on his back, while he cut "Freedom" on theirs; the work became part of his degree show. This was the still militant, actively anarchist Franko, but he was also responding, almost immediately, to Gina Pane's profoundly Catholic aesthetic. For her, pain and the cut are deeply symbolic concepts at stake within a discourse of redemption and transcendence. Pane, a lesbian, doubly stigmatised in a male-dominated Paris, created her actions and performances in a milieu where the mappings of Lacanian psychoanalysis onto the artist and the art work coexisted with an intense radicalisation of political protest. It was the time of Vietnam. A *dialogue de sourds* was the result of this crossing of discourses; the psychoanalytical and the political (Freud against Marx, Lacan against Althusser) seemed

fated never to communicate. Yet nowhere was this crossing in the present more intense, and the reference to the past more acute, than in Pane's performance of 1971, *Escalade non anesthésiée*. Here, before a small audience, on a metal frame she had created, she mounted barefoot, its ladder-like elements, set with razor-sharp pieces of steel on the rungs. Her own feet, slit, cut and bleeding, became symbols for the escalation of atrocities in Vietnam.

As a Catholic, "Pane knew that saints always communicated with people by means of their own body, stigmata, flagellations, swoons, were on one hand the symptoms of a manifest sanctity, and on the other the empirical certainty of the existence of the divine." [8] The body, then, had always been a devotional tool, martyred or erotic, and the wound a focus for adoration, mystic trances, transformations, divine music:

O Cult of the Shed Blood

O Window of Paradise

O Place of Refuge

O Sepulchre of Pilgrims

O Nest of Clean Doves

O Furnace of Love

O Treasure of the Catholic Church

O Stream of Living Water [9]

Despite the apparently masochistic dimensions of her work, Pane was eloquent in her own writings on the wound about what she described as its role within the 'transindividual body' of society:

The wound seeks out, indentifies and enscripts a certain malaise. It is at the centre of my practice, it is the cry and the blank of my discourse. The affirmation of the vital, elementary revolt of the individual. An absolutely non-autobiographical attitude. I lose my identity, finding it again within others, and the equilibrium between the individual and the collective, the *corps transindividuel*. [10]

But the personal must enter the political. She also said, "The action is over when the pain has anaesthetised my desire to dominate." [11] The showing of the wounds, the *ostentatio vulneris*, is both a founding religious trope for the paintings of martyrdom, and a calculated ploy, by Pane or by Franko, for a particular empathic reaction in the part of the spectator.

Pane was writing and teaching at a moment of the birth of *écriture féminine* in France, a reappropriation of the voice by woman, a voice previously suppressed—albeit through the matrix of language and the mother-tongue. The ecstatic writings of the female saints were the great precursors of this movement. Pane nourished her students on Bataille, and the inspirational writings of Laure (Colette Peignot) writings which

Bataille discovered and published only after his lover's early death. [12] The conjunction of the most sacred yet most problematic moment of the crucifixion, of death and the female sex comes in a passage of Bataille surely known to Pane. In his epiphanic, erotic novella, *Madame Edwarda*, at the precise moment when the narrator kneels to lick Edouarda's guenilles, the purple rags of her sex, he evokes Christ's wound and with it his cry from the Cross, *Eli, Eli lama sabachthani*—"My God, my God, why hast Thou forsaken me?" At the moment of absolute ecstasy, of absolute agony, of transcendence, the body itself dissolves to a cipher. For Bataille, this moment is acephalic and informed by a reading of Saint Angela of Folino. He discovered her writings at the same time as the mystic practices of medieval piety and the ecstasies of the crucified Chinese torture victim whose gazing, beatified body he published in the review *Documents*. [13]

Aktion! The Body Politic

Franko's Milan performance, *Aktion 398*, along with the exhibition *Who's going to lick my wound?* of performance relics and installation pieces, was again a conscious or unconscious *Imitatio Christi*. Provocative, of course, in an explicitly gay and AIDS-informed context, it would become his most symbolic moment of homage to and affiliation with Gina Pane, who, unbeknownst to him, had performed her *Azione sentimentale* in exactly the same space, then known as the Galerie Diagramma, in 1978 (now the Galleria Luciano Ingapin). This space was a centre of performance art in the 1970s, well known to alternative artists such as Marina Abramovic at the time.

> We saw her holding alternately a bouquet of white roses and a bouquet of red roses and incrusting thorns into her fore-arms... I understood that Gina Pane's action, which spoke of love and suffering showed how a body animated by thought is capable of integrating, interiorising and going beyond what denies it; what Gina Pane called a vital transcendence. [14]

As Franko performed, his body whitened and scarred, Lea Virgine entered the gallery, and, instantly aware of the fateful parallel with Gina, cried to the curator: "Please tell him to stop!" Yet, as its title demonstrates, *Aktion 398*, in which Franko wears a dog-muzzle and insists upon a one-to-one encounter, was also a salute to the Viennese Actionists. Franko's spiritual godfathers include Hermann Nitsch, whose psycho-dramatically constructed performances extended the notion of action painting when he was splashed with animal blood in 1962; Otto Muehl, whose *Material Aktion*, three years later involved plethoras of food, blood, body fluids; Günther Brus, whose *Breaking Test* cut the body with razor blades to the point of exhaustion, and Rudolph Schwarzkogler, whose third *Aktion* marked the high point of his collaboration with a photographer in rituals of critical self-observation. Franko's different performances of *Aktion 398* with variations for Mexico City, Birmingham, Antwerp, Malmo—or *I Miss You*, as it took place in London, Antwerp or Turin, are likewise meticulously documented. There are aerial versus ground shots, close ups of scars or medical apparatus, and commemorations of the beautiful boys—Kristian or Stuart—who acted as his assistants.

above: Gina Pane, *Azione Sentimentale*, 1973. Courtesy Courtauld Institute of Art.

Again, the Viennese Actionists posited both sexual liberation, a Sadean outrage *aux mœurs*—and the possibility of political readings of the body as body politic. To express a grief or an outrage in their works commensurate with Austria's blindness–with Second World War atrocities—would have been impossible: the cutting, the excrement, the body fluids on stage simply indicated the gap, the chaotic *mise en abîme*—a disruption which aimed to fling the 'real' and its everyday body into the abyss—an abyss perpetually gaping if anyone cared to look. Emissions from the body, like the scream, carried their own imperatives and meanings. [15] Exasperation with art objects and the art world imperiously dictated a transgression of boundaries, a return to body-frontiers—to these primal screams, while the body itself became an ensign representing a whole anthropology of purity and danger: "Soiling, (*la souillure*), in itself is scarcely a representation, and this is linked with a specific fear which stymies reflection: with soiling and dirt we enter into the reign of Terror." [16]

Kazuo Shiraga's *Challenging Mud*, 1955—the semi-naked artist writhing in mud and shingle, a key work of the Japanese Gutai group, described in the authoritative *Out of Actions* catalogue as aiming to make "an essentially two-dimensional painting" would, of course, have been read by his contemporaries as a tragic metaphor of Hiroshima: tragic but with all the (neo)dadaistic absurd of the non-commensurate, of the generations separated from those who suffered, by a trick of time or of space. [17] Chris Burden in Los Angeles, challenged as to the pertinence of his dare-devil performances, his scrapes and pains, his 'courage', in contrast with his peer group who were actually risking their lives in Vietnam, accepted this absurd, this non-equivalence—a non-equivalence parallel to the blood scraped from the male face in Martin Scorsese's 1967 short, *The Big Shave*—or that of Pane's *L'escalade*. [18] Yet for the Viennese Actionists, for Pane or for Burden, actions were a way of pushing life to its limits, living *in extremis*, that created a personal and political resonance with those other, anonymous solider's lives. "War is the strong life, it is life *in extremis*... pacifists ought to enter more deeply into the aesthetical and ethical point of view of their opponents", claimed William James, as early as 1910. [19] We do not choose who we are, but we can choose the subjects or the people with whom we wish to engage.

With the issue of the body politic as metaphor comes the question of how legitimately the individual artist, like Christ, or a scapegoat or shaman in more primitive societies, can embody or redeem "the sins of the world". As a corollary comes the clash of conflicting emotions in the onlooker, whose empathic projections involve a visceral identification at some level with the performer. These feelings may often be hard to reconcile with the interpretations of the intellect. At a second remove for the spectator also, comes the clash—the unbridgeable gap already mentioned—between psychoanalytic and political interpretations of a piece: the Other's body as owned, lived, excited, stimulated, scarred: the body sacrificed as a symbol for the community.

How in postmodern society, in Blair's glitzy and rotten Britain, might Franko's work serve as a comment on the body politic? The founding premise, even of the sado-masochistic community, is the rule of consensuality: it is surely around this notion, one could argue, that the relationship between rulers and ruled in life today has gone profoundly awry.

In *(Per)versions of Love and Hate*, Renata Salecl has recently attempted to collate practices such as clitoridectomy, body piercing and performance art within a synchronic and anthropological vision, in which self-cutting (mutilation/decoration) is defined as the inscribing of an irreversible and ineradicable 'real' upon a postmodern body adrift in a valueless and simulacral society. It is also an expression in Lacanian terms, she argues, of anger and disappointment at the collapse of authority of the big Other—or the masochist's constant attempt to reestablish Him. She introduces a Deleuzian reading of masochism into the performances of live artist, Bob Flanagan, describing neurotics who "try to show how they are not essentially marked by the law, since they can openly play with castration rituals on stage." [20] But, while writing from the States rather than London, Flanagan's own manifesto *Why?* (Why cut? Why cut on stage?) is far more eloquent a summary of his condition—in its disjunctures, its rushing together of past and present, its memories of childhood, of humiliating nuns and the Catholic world view—than Salecl's post hoc pontifications:

> WHY?
> Because it feels good; because it gives me an erection; because I'm sick; because there was so much sickness; because I say FUCK THE SICKNESS; because I like the attention; because I was alone a lot; because I was different; because kids beat me up on the way to school; because I was humiliated by nuns; because of Christ and the Crucifixion; because of Porky Pig... because of NO PAIN NO GAIN; because SPARE THE ROD AND SPOIL THE CHILD; because YOU ALWAYS HURT THE ONE YOU LOVE.. [21]

A proliferating literature about self-mutilation, including its British dimensions, creates a context which may now be seen to intersect with the absolutely alternative axis of an international, second generation of performance artists. [22] The contemporary medical and psychiatric professions were slow to take the long history of tattooing, cutting and body modification on board within its anthropological perspectives. [23]

Franko heard of Fakir Musafar's Modern Primitives movement in the spring of 1990; he encountered the work of Stelarc and Orlan between 1992 and 1995, the year he met Annie Sprinkle and Ron Athey—the latter at the wake of a mutual friend who had run the Milch gallery, where the FIST club started (the setting for Franko's first performance). Lois Keidan's *Rapture* festival of live art at London's ICA, in late 1995, which brought so many artists together must be acknowledged here. Shows such as *Rosso Vivo*, 1999, in Milan connect this performance generation with artist such as Louise Bourgeois, Cindy Sherman, Andres Serrano, Jan Fabre, Pierre et Gilles, and Jana Sterbak, for whose work Franko has a particular admiration. At *Rosso Vivo*, Franko's piece, *I Love Mr Woodcock*, consisted of a very large installation of his objects— the first time his work as sculptor/installation artist had been seen on a large scale internationally.

Skin to the wind

But a dimension is missing here in our engagement with Franko's work: the dimension of sound, voice and music. The first flayed body in art was Marsyas's, stripped of its flesh and nailed to a pine tree: a punishment for attempting to rival, with his magic flute, the God Apollo's lyre-music. The flaying itself—origin of the

classical *écorché* (and Sterbak's *Meat Dress*) relates both to the fabrication of musical instruments—hence art itself—and to the ritual flaying of a sacred king (Orpheus with his lute ripped apart by the maenads of his cortege). [24] Body, music, torture—always intimately linked. Just as torture itself, its involvement with the imperative of the Question, is linked to the sound of the sob, the scream, the confession. [25]

Just as Orlan sites her identity not in her mutating appearance but in her voice, so Franko's voice, coming from his mouth of golden teeth—terrifying and precious—is quintessential. Like his body, his voice is a hybrid, a mixture of languages, accents, elisions, very sensual—brutal if needs be.

And beyond the voice, music. My first experience of Franko's performance work, *I'm Not Your Babe*, in Cardiff, was an overwhelming sensory experience: Franko came on stage to the sounds of the techno-industrial music of his long-time collaborator, Gavin Mitchell. Upright at first, Franko, his body whitened, bled from tubes in his arms onto a darkened, square-shaped stage fringed with silent, squatting onlookers. His own ebbing pulses beat in our ears with Mitchell's music, whose counter-strains insistently echoed Franko's will to stand and not to stumble, to kneel and not to fall, to lie still in a spreading pool of blood—while liquid nitrogen was released intermittently on stage in pillars of cloud, blurring our vision of the body, creating visual passages as space seemed to collapse around the collapsing body, turning the red blood grey. The blood itself mixed with the white pigment on Franko's body, as he moved and rubbed himself on the floor, frantic at first, then limp—"I'm painting it" says Franko. His special effects turn every performance into a *Gesamtkunstwerk*—a total work of art—mirroring life. [26]

Yet *I Miss You*, at Beaconsfield, Vauxhall, in a space under the railway arches, played deliberately, in contrast, with silence. The silence was orchestrated by the apocalyptic rumble of trains overhead, a rumble that made the dank, brick walls vibrate as Franko bled. One recalls the debt Gina Pane acknowledged towards John Cage. In this performance, silence was timed and made space, as Franko, bleeding again from the arms, paced down a white, floor-level catwalk. Sitting on the cold floor, I looked up as he approached, finally seeing the body in close-up, the two raised gashes on his side, aware first of the sound of his feet, then steady breaths through the nose, finally the muffled pat of drips of blood onto the linen as he walked past. The sound of breathing intensified our compassion, our sense of helplessness. [27] Occasionally he would raise his arm to his face, to clear his vision, wipe his nose; as he weakened he held himself, his left arm clasped across his chest. And this was another painting: cold colours at first, the white body illuminated by the blinding spiral fuses of oversized lightbulbs; the catwalk darkening gradually, red blood becoming brown as the splashes broadened, caked, hardened.

Haute Couture/Home

Spotted with the black and crimson trails of so many performance pieces, the canvas paths have been gathered, like so many Turin shrouds; raw material to be recycled into new collaborations that create a bridge between Franko's performance works and his objects as relics. "Beauty functions like a bridge" says

Franko. Following a catwalk performance in Antwerp, the used canvas on the floor was carefully rolled up, dried, cut and nailed onto wooden stretchers, like paintings. The idea of recycling the material from performances was born here.

Sewing had been previously a sewing of the skin, a question of suture. Franko's lips sewn up with curved needles in protest against the censorship surrounding the Spanner Case. [28] Now sewing becomes healing and making. Home, this spring, will show the miraculous transformation of the catwalk cloth into clothes and furniture: from the public spectacle of the fashion show *détourné*, to the domestic, from Franko's experiences at their most extreme and most transcendental, back to the family narrative and a real house.

Home, in Camberwell, will house on one floor the costumes created from Franko's performance canvases; his pinball machine will be installed in the living room with the neon piece, *Oh Lover Boy*, his drawings will be pinned up in the nursery. [29] A sense of Pirandello will surely haunt this house: costumes on display in search of characters, rather than characters in search of an author.... The creators behind the costumes are also invisible presences: Hiroyuki Oyoshi from Tokyo, Anne-Sofie Olrik from Copenhagen, Lorna Lee Leslie, Ian Wallace, Kova Katak, Lee Benjamin and Mayu from London; these are friends from art school, friends from the club scene, famous designers: a strange convergence. There will be a bed with bedsheets, a sofa, chairs, a wardrobe, even a clock, to set the scene of a blood-spattered crime: the classic *Lustmord*?, a contemporary Passion Play? There is a strange sense of anachronism: the tear of the seamless robe; the struggle over; blood spilt before the superbly elegant garments are inhabited. The mood will vacillate constantly between the decorative, the forensic and the uncanny—the absent hand which stained the bloody glove.... Wallace's stocky suit, made to measure for Franko, certainly gives him the air of a mafia Godfather; but Leslie's outfit, displayed on a rack or stand, headless, disembodied, with strangely extending legs dragging on the floor and Mayu's suit cut with holes and extravagantly sequined, suggest more sinister and elaborate scenarios. Katak's asymmetrical ball dress seems stifled, arrested in its movement, longing to shed its rough material which smacks too much of the hospital. It is superbly complemented by Ogden's simple nurses' uniform, the red cross replaced with Dalmatian spots of blood. The most disturbing work is surely Benjamin's straitjacket, measured onto Franko's body. An anachronism? There is an uncanny suggestion of recidivism here: might the violence implicit in the before or after of the piece's fabrication break out? Might Franko, himself, have to be restrained? We feel the threat of the asylum. Artaud's pain again, Franko's pain; yet a sense of both redemption and the insistence on artifice as dripping blood is transformed into this procession of figures, this masquerade awaiting a libretto—another London melodrama?

Back in the East End, not so far from Toynbee Hall and Franko's studio, the Great Eastern Hotel, Liverpool Street stands refurbished; it is constructed upon the site of London's original madhouse, Bedlam. [30] A neon sign above the bar will soon read: "I feel lonely, please call me 0775 992 4581." It's Franko. [31]

With thanks to Franko B, Gabriele Finaldi, Mark Gisbourne, Duncan McCorquodale and Adrien Sina for their help.

NOTES

1 Artaud, Antonin, *Saint Francis of Assisi*, (1922), *Antonin Artaud, Selected Writings*, introduced by Susan Sontag, Berkeley: University of California Press, (1973), 1988, p. 5.

2 White, Edmund, *Genet*, London: Chatto and Windus, 1993, p. 182.

3 Genet, Jean, *Haute Surveillance*, Paris: Cineastes-Bibliophiles, 1947, an erotic play with three male characters in prison.

4 See the parallels with the club universe of *Torture Garden. From Bodyshocks to Cybersex... A Photographic Archive of the New Flesh*, London: Creation Books, 1996. The name comes, of course, from Octave Mirbeau's colonial parable of 1899, *Le Jardin des Supplices*, irrevocably linked with Rodin's erotic watercolours— blood wipes' *avant la lettre*—which appeared with a luxury edition of Mirbeau's text in 1914.

5 See Brigid Brophy's essay: "Our Lady of the Flowers", in Brooks, P. and Halpern, J., eds., *Genet, A Collection of Critical Essays*, New York: Prentice Hall, 1979, pp. 69–70.

6 Couturier, Père Marie-Alain, in *Les chapelles du Rosaire à Vence et de Notre-Dame du Haut à Ronchamps*, Paris: Les Éditions du Cerf, 1955.

7 Franko B, *Shelf Life*, London: Two10 Gallery/The Wellcome Trust, 2000, pp. 6–7.

8 Deho, Valerio, "Corpo d'amore/Body of Love", *Gina Pane, opere 1968–1990*, Milan: Charta, 1998, p. 35.

9 Gray, Douglas, "The Five Wounds of our Lord", *Notes and Queries*, February–May, 1963, pp. 50–51, 82–89, 127–135, 163–168, with an extensive bibliography.

10 Pane (my translation), quoted without a reference by Anne Tronche, " Les enneigés blessés" in *Gina Pane*, Le Mans: Beaux-Arts, (École supérieure), 2000, p. 30. Compare also Pane's use of the truncated and elongated red cross in the minimalist sculptural installations, such as *The Martyrdom of Saint Sebastian after a Composition by Memling, Score for a Body*, 1984, pp. 70–71.

11 *Nourriture/Actualités TV/Feu*, 1971, involving a dedication to fire, in *Gina Pane, opere*, p. 27.

12 Laure (Peignot, Colette) *Écrits*, Paris: J.J. Pauvert (U.G.E.), 1978. See Nicole Schwarz in "Gina Pane et l'enseignement artistique' in *Gina Pane*, pp. 102–103.

13 Doncoeur, P., *Livre de la b. Angèle de Foligno*, Paris, 1925; see also his *Dévotions et Pratiques mystiques/symboliques du Moyen Age*, Paris, 1925.

14 Nicole Schwarz, on seeing photographs of *Azione sentimentale*, in a show at the Palais des Congrès, Le Mans, in *Gina Pane*, p. 105.

15 Aydemir, Murat, *Images of Bliss, Ejaculatory Masculinity and Meaning in Literature, Film, Art and Theory*, ASCA Research bulletin, (work in progress, Amsterdam).

16 Paul Ricœur, quoted without date in the original French in Mary Douglas's classic: *Purity and Danger An analysis of the concepts of purity and taboo*, (1966), London: Ark, 1984, p. 31 (my translation: *la souillure* is linked to ideas of defiling, staining, body wastes, etc.).

17 Schimmel, Paul, "Leap into the void: performance and the object", *Out of Actions, between Performance and the Object, 1949–1979*, Los Angeles/London: The Museum of Contemporary Art/Thames and Hudson, 1998, p. 25.

18 Scorsese, Martin, *The Big Shave*, USA, 1967, 6 minutes: a young man (Peter Bernuth) shaves his face again and again, until it is covered in blood.

19 James, William, "The Moral Equivalent of War", (1910), *The Writings of William James*, New York: Random House, 1967, pp. 661, 666, quoted in Franser, John, *Violence in the Arts*, Cambridge: Cambridge University Press, 1976 (2nd edition), p. 105.

20 Salecl, Renata, "Cut in the Body, from Clitoridectomy to Body Art", *(Per)versions of Love and Hate*, London: Verso, 1998, pp. 140-168.

21 Bob Flanagan, *supermasochist*, RE/Search Publications, 1993, pp. 64-65. In terms of a certain infantilism in Franko's work, compare Flanagan, *The Kid is the Man*, Bombshelter Press, 1978.

22 Favazza, Armando A., *Bodies Under Siege, Self-Mutilation and Body Modification in Culture and Psychiatry*, Baltimore and London: John Hopkins University Press, [1987], 1996. His account ranges from Karl Menniger's pioneering *Man against Himself*, 1938, to accounts of the British scene: Edward Morgan's *Death Wishes*, 1979. See also Strong, Marilee, *Bright Red Scream, Self-Mutilation and the Language of Pain*, London: Virago Press, 2000.

23 Fakir Musafar founded Modern Primitives in 1985, after his personal 'coming out' at the first international tattoo convention, Rena, Nevada, 1978. See his "Body Play: State of Grace or Sickness" in *Bodies Under Siege*, pp. 325-334.

24 Graves, Robert, *The Greek Myths*, vol. 1, pp. 80-83; Athene's double-flute, found by Marsyas, was made of stags' bones; the bark of an alder-shoot is flayed to make a shepherd's pipe.

25 See Elaine Scarry's classic discussion in *The Body in Pain, the Making and Unmaking of the World*, Oxford: Oxford University Press, 1985, pp. 140-141, 281.

26 *I'm Not Your Babe*, Chapter, Cardiff, 24 October 1997, and Franko in conversation, 2 March 2001. Mitchell was attached to the group Identical, and will be working with Franko in Denmark for *You Make My Heart Go Boom, Boom*, summer 2001. Here Franko will collaborate on special effects for the first time, with the installation artist Hans E. Masden, who will light the piece including Franko's light box/bed. See also Franko's CD by Philip Walsh with dogs barking—produced by Franko B and Gilles Jobin, 1998.

27 See Didier Anzieu's concept of the *moi-peau* ("skin/me") as "the sonorous envelope of the self" in *Psychanalyse et Langage. Du corps à la parole*, Paris: Dunod, 1977.

28 The Spanner Case concerned the prosecution of a group of gay men who were involved in private consensual sadomasochistic 'practices'.

29 *Oh Lover Boy*, Home, 1a, Flodden Road, London SE5, 4 May-3 June, 2001.

30 The Priory of St Mary Bethlehem, was founded in 1247 by the Bishopsgate Sheriff, Simon Fitz Mary. It moved to palatial new buildings in Moorgate in 1676, then to Lambeth (now the Imperial War Museum), and today functions as the Bethlem Royal Hospital Archive and Museum in Kent.

31 The group show, *Please Disturb Me* will run at the Great Eastern Hotel from 23 March through April, 2001.

Franko B was born in Milan, Italy in 1960 but has lived in London since 1979. After a foundation course at Camberwell School of Art (1986–1987) he trained at Chelsea College of Art (1987–1990) graduating with a BA in Fine Art. He has been working with a variety of art forms since 1990 with projects involving video, photography, performance, installation and sculpture. He has presented his work internationally in a broad range of contexts.
Franko-b.com

Selected Work
Exhibitions
Franko B, Outside Gallery, London April/May 1996.
Who's going to lick my wound?, Luciano Ing-pin Gallery, Milan, March/April 1998.
Rosso Vivo, (group exhibition), at PAC (Museum of Modern Art), Milan, January/March 1999.
I Miss You, Toynbee Studios, London, April 1999.
I Miss You, Walter Van Beirendoncks Window Gallery, Antwerp, October/November 1999.
Exhibition Of Painting, The Centre Of Attention, London, January/February 2000
Oh Lover Boy (collages), Chamber Of Pop Culture, London, April/May 2000.
I Feel Lonely Please Call Me, The Great Eastern Hotel, London, (group show) 23 March 2001.
Oh Lover Boy, Home, London, May 2001

Performances
Mama I Can't Sing Part 2 (Rapture), Institute of Contemporary Arts, London, November 1995.
Mama I Can't Sing Part 3 (Totally Wired), Institute of Contemporary Arts, London, April 1996.
I'm Not Your Babe Part 1 (Totally Wired), Institute of Contemporary Arts, London, May 1996.
I'm Not Your Babe Part 1 and 2, Institute of Contemporary Arts, London, December 1996.
I'm Not Your Babe Part 3, Il Corpos Terminato Festival, Florence, Italy, May 1997.
I'm Not Your Babe Part 1, Eurocraz Festival, Zagreb, Croatia, June 1997.
Aktion 398, Luciano Ing- Pin Gallery, Milan, March/April 1998.
Aktion 398, Ex Teresa, Mexico City, October 1998.
Aktion 398, The South London Gallery, London, November 1999.

Aktion 398, Arts Admin, Toynbee Studios, London, 18 March 2000.
I Miss You, Beaconsfield, London, 14 April 2000.
I Miss You, Fierce Festival, in association with the Ikon Gallery, Birmingham, 26 May 2000.
I Miss You, Art Live, Torino, October 2000.
Aktion 398, Zurich, December 2000.
Oh Lover Boy, Live Art At Kanonhallen, Copenhagen, January 2001.
Oh Lover Boy, Beaconsfield, London, 28 April 2001

Oh Lover Boy, Fierce Earth,
Birmingham, June 2001

Video and Television
*When I Grow Up I Want To Be
Beautiful*, National Film Theatre,
London, 1993.
Protect Me, Midnight Under Ground,
Channel 4 Television, August 1996.
Protect Me, Renegade TV,
Channel 4 Television, August 1997.
Body Art, The South Bank Show,
LWT Television, April 1998.
Dead Mother, The Lux,
London, February 2000.

I'm Not Your Babe 1 and 2 (Extract), Performing Bodies,
Tate Modern, London, October 2000

Publications
The Male Nude, Manuel Cooper, London: Routledge, 1995.
Franko B, Milan: Costa Nolan/virus mutation, 1997.
Identita Mutanti, Francesca Alfano Miglietti, Milan: Costa Nolan, 1998.
Franko B, Lois Keidan and Stuart Morgan, London: Black Dog Publishing Limited, 1998.
Rosso Vivo, Milan: Electa, 1999.
The Artist's Body, Tracey Warr/Amelia Jones, London: Phaidon, 2000.
Body Art and Performance, Lea Virgine, Milan: Skira, 2000 edition.
Exposures, Manuel Vason, Lois Keidan, Ron Athey et al, London: Black Dog Publishing Limited, 2001.

Conferences/Debates
Upgrade 3 Symposium, Niedescachesen, February 1999.
Milano Oltre Symposium, Milan, October 1998.

Guest academic engagements to date include: Goldsmiths College of Art, London, 1991, 1996, 1999; Hull
University 1996; Ljubljana University 1997; Academia Delle Belle Arti In Bologna 1997–2000; Wimbledon
College of Art, London 1997, 1999, 2000; Bergen Art Society 1998; University of North London 1999; Guildhall
University, London 1999; Courtauld Institute of Art, London 1999, 2000; Central St. Martin's School of Art,
London 2000; New York University 2001.

Selected Critical Review
don't tell it,
December/January 1996;
The Independent,
26 April 1996;
Art & Design; Curating Special Issue,
1997;
virus mutation, 1997;
live art magazine,
July/September 1997;
Time Out,
10/17 December 1997;
Total Theatre, winter 1997/1998;
La Republica, 13 March 1998;

Il sole 24 ore.
15 March 1998;
The Guardian.
1 April 1998;
The Independent.
1 April 1998;
Pais Vasco.
21 May 1998;
Bergens Titende.
9 October 1998;
Theatre and Drama Review. 42/4 (t 160)
winter 1998;
The Guardian.
2 March 1999;

La Stampa.
26 March 1999;
live art magazine.
no 30. 1999;
De Standard.
29 October 1999;
De Standard.
2 November 1999;
Art Monthly.
December 1999;
Studija. no 3.
2000;
sleaze nation.
February 2000;
The Sunday Independent.
22 April 2000;
The Independent.
26 April 2000;
Flux.
April/May 2000;
butterfly.
5 May 2000;

The Observer.
30 July 2000;
live art magazine.
no 31. 2000;
Total Theatre.
December 2000;
Il Corriere della Sera.
24 January 2001;
Politiken.
27 January 2001;
Dazed&Confused.
March 2001;
Paris Match.
April 2001.

I would like to acknowledge that without the commitment and belief of Manuel Vason this book would not have happened. We met in April 1999 at the presentation of my video installation I Miss You, at Arts Admin in London. By May of the same year we had started our collaboration. We didn't know what would come out of this, or that we would spend a lot of time traveling and working together; but I knew that I liked and trusted the passion, energy and ambition that he and his work showed. At the outset all we really knew was that our collaboration was not going to be that of the usual model/photographer relationship. This was made very clear by both of us early on as it was not what we were looking to explore—we wanted to grow through our working together not only as artists but as human beings. Personally I feel that this was a risk well worth taking, and I trust that this book and our friendship is a testament to this.

I would also like to express my thanks to all my dear friends and everyone that has inspired, supported, assisted and collaborated with me in one way or another; for their patience, trust, generosity, honesty and love (not only on this project) and for keeping to do so. Thank you.

I would like to acknowledge the financial support for this project by Susie Kruger, Tom Vulliamy and Paddy Glackin.

A very special thank you to:
Mr Athey; Stuart Barclay; Mr Etchells; Fam and Cesare Fullone at virus mutation; Ernst Fischer; Daniel Gosling; Manick Govinda and everyone at Arts Admin; Gritt; Julie and Jet; KK; Lois Keidan at the Live Art Development Agency; Catherine Grant and Duncan McCorquodale at Black Dog; Paul and Maria at PK+MB; Gray Watson; Diane White; Sarah Wilson; Mr Woodcock.

Supported by Audio Arts and Cida.

To all those that are dear to my heart.

Manuel Vason was born in Padova, Italy in 1974. Whilst studying at the University of Social Science, Padova, he decided to become a photographer, and moved to Milan. He found a job as a studio assistant at Industria Superstudio where he worked for two years with some of the most highly regarded photographers in the fashion industry. In 1998 he moved to London and whilst assisting the photographer Nick Knight started working beyond the limits of fashion photography. Along with *Oh Lover Boy* another book of Vason's photographs, *Exposures*, is being published by Black Dog this year.

Gray Watson is a lecturer and writer based in London. He was formerly editor of Performance magazine. He is co-author of *Derek Jarman: A Portrait* (Thames and Hudson, 1996) and *Body Probe* (Creation Books, 1999). He has conducted numerous interviews for *Audio Arts*, amongst which include those with Chris Burden, Hermann Nitsch and Annie Sprinkle, as well as Franko B. His writing has been published in a wide variety of art magazines, including *Art & Design, Art International, Artscribe, Flash Art, Kunstforum* and *Parkett*, and he has lectured and participated in symposia at numerous colleges, galleries and museums in England and abroad. He is currently Senior Lecturer in History of Art and Contextual Studies at Wimbledon School of Art.

Sarah Wilson is a Reader in Art History at the Courtauld Institute of Art, University of London, where she teaches a course "Beyond Painting and Sculpture: Happenings and Performance through the Twentieth Century". She is currently preparing *Paris, Capital of the Arts, 1900–1968* for the Royal Academy London and Guggenheim Museum, Bilbao (2000). She has published extensively on art in France, notably for the Centre Georges Pompidou, and has written on the performance artists Orlan and Michel Journiac.